82237

W9-BKK-411

3 1762 00154 0057

A Meditation of Fire

The Art of James C. Watkins

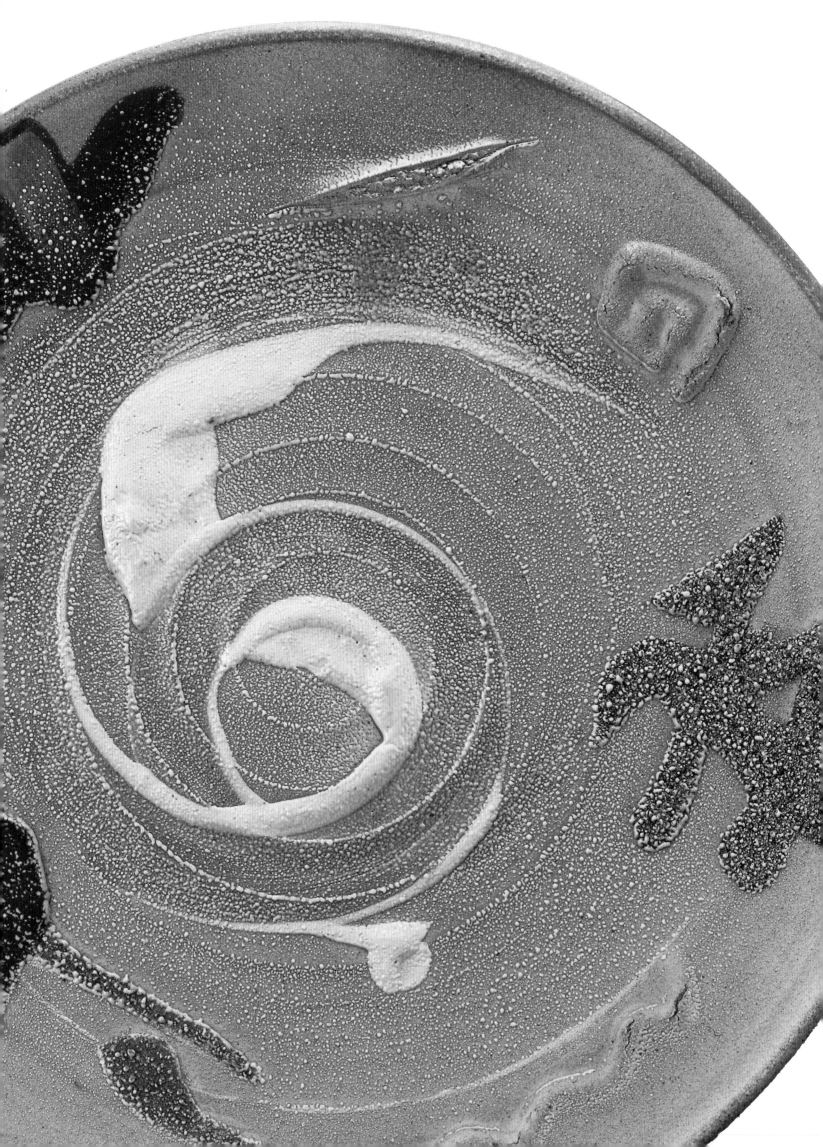

A Meditation of Fire

The Art of James C. Watkins

Kippra D. Hopper

PHOTOGRAPHS BY
Mark Mamawal

FOREWORD BY
Michael W. Monroe

TEXAS TECH UNIVERSITY PRESS

© Copyright 1999 Texas Tech University Press

All rights reserved. No portion of this book may be reproduced in any form or by any means, including electronic storage and retrieval systems, except by explicit, prior written permission of the publisher except for brief passages excerpted for review and critical purposes.

This book was set in Berkeley Oldstyle and News Gothic Condensed. The paper used in this book meets the minimum requirements of ANSI/NISO Z39.48-1992 (R1997). ∞

Jacket photo: James Watkins sits with his double-walled caldron, *Ritual Display,* in Caprock Canyons in West Texas.

Design by Melissa Bartz

Printed in Hong Kong

Library of Congress Cataloging-in-Publication Data
Hopper, Kippra D.
 A meditation of fire : the art of James C. Watkins / Kippra D. Hopper ; photographs by Mark Mamawal ; foreword by Michael W. Monroe.
 p. cm.
 Includes bibliographical references.
 ISBN 0-89672-419-0 (cloth : alk. paper)
 1. Watkins, James, 1951- –Themes, motives. 2. Pottery–20th century–Texas.
I. Watkins, James 1951- II. title.
NK4210.W34H66 1999
738'.092–dc21 99-10124
 CIP

99 00 01 02 03 04 05 06 07 / 9 8 7 6 5 4 3 2 1

Texas Tech University Press
Box 41037
Lubbock, Texas 79409-1037 USA

800-832-4042

ttup@ttu.edu

Http://www.ttup.ttu.edu

(previous page) From the *Painted Desert* series, platter form, stoneware, 1989

To Marcia M. Abbott, Ph.D.,

for wisdom, compassion and love on the journey . . .

—kdh

A Meditation of Fire: The Art of James Watkins was supported generously by the <u>CH</u> Foundation and the Helen Jones Foundation in honor of the sisters Christine DeVitt and Helen DeVitt Jones.

CONTENTS

ACKNOWLEDGMENTS

A friend once gave me a wonderful piece of jewelry, a pin that includes the words "Art Saves Lives." I always thought I knew what that meant, but I have come to realize through this project the true meaning of those words, as I believe they have echoed true for James, Mark, and myself. We have been able to share one another's art—to blend our genres—during the three years we have traveled on this project.

The endeavor has been rich, as we all feel fortunate to have worked and spent time with one another. This has been substantially a labor of love. Individually and collectively, we have gained sustenance through our friendship and through the work. We have experienced the best that life has to offer: love and work, en masse.

Thank you to Dr. Robert and Louise Arnold for finding the financial support to make this work possible. The CH Foundation, of Lubbock, funded the project with a $35,000 grant. The Helen Jones Foundation, also of Lubbock, supported this work with a $25,000 grant. Thank you to Beverly Tucker and Jennifer Nielsen, both of the Texas Tech University Office of Development, for helping to write the initial grant applications for the book.

Thank you to Carole Young, director of the Texas Tech University Press, for immediately being supportive of the project. Also of Texas Tech University Press, Melissa Bartz, your design of the book is stunning. And, thanks to Marilyn Steinborn for your typesetting expertise.

Thank you to Margaret S. Lutherer, former director of the Texas Tech University Office of News and Publications, for nurturing our intellectual growth. Thank you to photographer Darrel Thomas for much appreciated advice and support. Thank you to Grant Hall, associate professor of anthropology at Texas Tech University, for taking us to sites of American Indian pictographs that we otherwise never would have seen. Thank you to Wyman Meinzer for contributing your magnificent photographs of sandhill cranes.

Thank you to Gary Edson, director, and Denise Newsome, exhibit design manager, of the Texas Tech University Museum for arranging the Twenty-Year Survey Exhibition.

Thank you to Henry and Sellie Shine for the garden in which I find myself. Thank you to Lanie Dornier, Charles Griffin, D. Kent Pingel, Leigh Mires, Kristie Deschesne, Mayme Allen, Gwen Sorell, Sharlia Upton, Dr. Elizabeth Davidson, Amy Taylor, Marilyn Montgomery, Sally Logue Post, and Judi Henry for being exceptional readers and editors.

Thank you to the animal spirits who cross our paths, especially to our companion animals Sojourner and Sasha, who passed during the creation of this book.

Mostly, thank you to our families and friends for their love and support of our art. Thank you Sara Waters, for your encouragement, guidance, and studio space. Thank you Dawn Mamawal for your inspiring and ever-present energy. Thank you Linda and Jerry Hopper for believing it could be done.

Nothing compares to loving one's work and working with one's friends in an artistic endeavor. Thank you to James and Mark, for sharing with me your creative spirits. Art Saves Lives.

FOREWORD

Tell me the landscape
in which you live, and I
will tell you who you are.
—José Ortega y Gassett

James C. Watkins lives and dreams in the monumental: earth, water, air, fire. Intensely aware and present to the American southwestern landscape of his daily life, Watkins is simultaneously conscious of the interior landscape of his memories and dreams. His fertile imagination and dynamic creative expression are grounded in an intimate experiential knowledge of diverse, complementary internal and external landscapes.

The massive platters and caldrons of James Watkins yield immediate tangible evidence of his sophisticated technical mastery. At the same time, his forms transcend the technical and attest to his personal affinity with the mythic dimensions of the multiple lands he inhabits. Watkins' forms awaken in us a sense of awe, an acknowledgment of that which is by nature, monumental. His double-walled, wheel-thrown, and hand-built caldrons mirror his contemplative, responsive spirit. He is alert to paradox and respectful of magic, mystery, and ritual. Creatures of his diverse landscapes frequent his clay forms. Birds of free flight and snakes of fluid movement hover on and coil out of his vessel's rims. Formidable guardians, they assume the role of familiars protecting secrets sealed within the caldron's double walls. These hidden, hollow sections between the interior and exterior walls invite the protection of familiars and provoke our own curiosity. We seek to know, to see, to hear what is within, what is whispered in the echo chamber. Memories, subconscious impressions of dark canyons, caves, and crevices begin to stir within us. We walk the landscape with James Watkins. Looking down into canyons and up at cliffs, we touch the multifired, tactile surfaces and recall our own experience of the natural world.

James Watkins reveals through the metaphorical language of ceramic forms his understanding of and passion for the land. He has not restricted himself to perfecting his singular vision but has reached out to young artists. As a teacher and mentor, Watkins is a supportive and inspiring guide. His teaching is not limited to the studio environment. His platters and caldrons silently, but insistently, teach us to stop, to strive for clarity of perception, and to be sensitively attentive to the landscape we inhabit. As a contemporary alchemist, he initiates us to the ancient art of seeking the essence through transformation by fire. His forms forcefully remind us to take upon ourselves the discipline of learning to see, of questioning where we stand and how we move in relationship to the earth. James Watkins speaks with conviction and teaches us to listen:

"Art is food for the soul. The discipline of making art is not an end in itself but a means of making the individual more intimately aware of phenomena great and small in the external world and the internal world of visions."

We thank James Watkins for his persistent dedication to a personal vision that is intimately connected to the archetypal sensibility we all share. Thank you for awakening us.

Michael W. Monroe
Executive Director
American Crafts Council

INTRODUCTION

Though we travel the world over
to find the beautiful,
we must carry it with us
or we find it not.
—Ralph Waldo Emerson

Potter James Watkins and I share a love for the land. Throughout the three years we spent preparing this work, we traveled, along with photographer Mark Mamawal, to those spaces in Texas that have provided the greatest stimuli in Watkins' art—Caprock Canyons, Junction, Sonora Caverns, the Muleshoe Wildlife Refuge, Rattlesnake Canyon.

In Caprock Canyons, we are aware of eternity as we view ancient rock outcroppings. At the Muleshoe Wildlife Refuge, we are attentive to our connection to the sacred as we listen to the birds' echoes across the open prairies. At Rattlesnake and Seminole Canyons, we perceive the spiritual dimensions of our world as we enter through metaphorical doors of primitive humans' shelters. In the Sonora Caverns, we feel touched by magic as each drop of humidity falls from formations and lands on our skin. In Junction, we discover many rich forms of life, flowing in and around the Llano River.

Having a sense of place means one is acutely aware of his or her surroundings and the inherent beauty thereof. In West Texas, particularly, one must look with a patient eye to see the magnificence of these semiarid lands. One develops this keenness by becoming an intense observer and by taking nothing for granted in one's environment.

Each of the places we visited are vessels: They hold life, water, food, and shelter. And though remote, the places are so exceptional that they command us to convene there, to study these blessed lifelines and hallowed gathering places.

"If the landscape reveals one certainty, it is that the extravagant gesture is the very stuff of creation. After the one extravagant gesture of creation in the first place, the universe has continued to deal exclusively in extravagances, flinging intricacies and colossi down aeons of emptiness, heaping profusions on profligacies with ever-fresh vigor. The whole show has been on fire from the word go. I come down to see the water to cool my

eyes. But everywhere I look I see fire; that which isn't flint is tinder, and the whole world sparks and flames," writes Annie Dillard in her book, *Pilgrim At Tinker Creek*.[1]

In addition to the external places we decree to be so spectacular, we find other places on our journey within ourselves. These places consist of our memories, aesthetic ideals and spiritual quests. Watkins and I discovered that we share yet another path: Our mothers and grandmothers gave us the sense to live each day as an act of imagination. Creativity thrives in our choices great and small—inventiveness is a way of life.

Understanding that spirituality is the basis of art, Alice Walker writes in her essay *In Search of Our Mothers' Gardens* that some of our mothers and grandmothers did not have the luxury of being artists, but they were creative. Our mothers and grandmothers lived ingenious lives and brought beauty into our every day.

Walker writes: "Therefore we must fearlessly pull out of ourselves and look at and identify with our lives the living creativity some of our great-grandmothers were not allowed to know. . . . Her face, as she prepares the Art that is her gift, is a legacy of respect she leaves to me, for all that illuminates and cherishes life. She has handed down respect for possibilities—and the will to grasp them."[2]

James Watkins' vessels occupy internal and external spaces. They reflect a gentle and generous soul that takes nothing for granted and lives life in all its creative potentialities. His work is a meditation of fire.

Notes

1. Annie Dillard, *Pilgrim at Tinker Creek* (New York: Harper & Row, 1974), 9.
2. Alice Walker, *In Search of Our Mothers' Gardens* (San Diego: Harcourt, Brace, Jovanovich, 1983), 237, 241.

CREATION 1

We shape clay into a pot,
but it is the emptiness inside
that holds whatever we want.
—**Tao Te Ching**

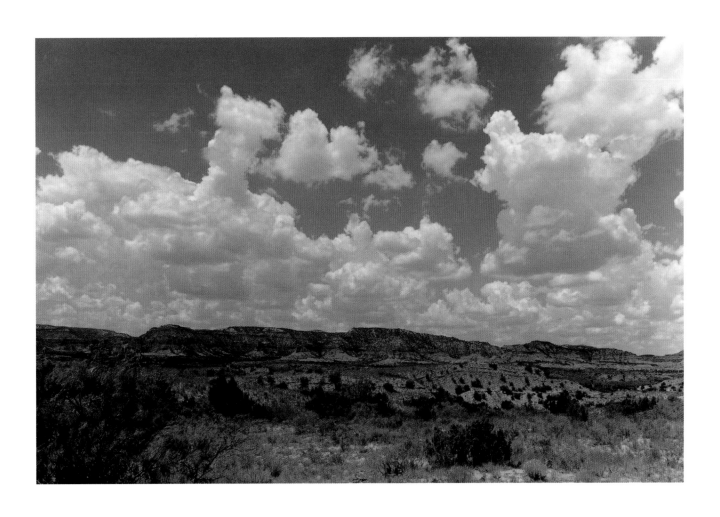

Standing on the artist's front porch, James Watkins and I look toward the northwesterly skies, peering at the Hale-Bopp comet, each of us tingling in the sort of excitement only nature brings. Inside, Watkins' son, Zachary, is composing synthesizer music, and his daughter, Tighe, is practicing the violin. Sara Waters, Watkins' wife, is in her studio, creating her own art and music. Watkins is spending his time these days constructing the bird figures that will extend from the rim of his latest huge, double-walled caldron, which he titles *Communion,* a part of the *Guardian* series.

In this home, across from a city park, all beings feel free to come and go, to find warmth, generosity and care. Most recently, a new cat named Sasha has taken up with the Watkins family. I myself am here for my own needed comfort.

Watkins and I talk about being in West Texas, a space of rich experiences for sojourners who see her beauty. We recognize that West Texas supports a pioneer spirit and a rebellious independence in her artists. And like the forces of her storms—sometimes ruthless and harsh, sometimes cleansing and nourishing—creativity flourishes.

In these mostly quiet skies, we have watched while thunderheads have built above us, and then have witnessed the rupture of the roaring clouds. Lightning splits the vistas, and the Big Dipper pours its rain onto plains that crack into canyons.

For more than 12,000 years, humans, prairie dogs, coyotes, buffalo, and burrowing owls living on this land have sought shelter from hail, flash floods, tornadoes, and a blazing sun. Here on the Caprock, at the foot of the Rocky Mountains, the same forces that urge us to seek shelter also sustain us.

On the Llano Estacado, one of the flattest areas of the world, horizons extend across open spaces unbroken by tall landforms. These vast skies captivate us, allowing us to be, letting us move in our own directions. We find our home here.

Watkins always has sensed a connection to the land. The potter has come to be known for his double-walled caldrons and two-foot diameter platters that exhibit his appreciation for the milieu of the Southwest.

His ideas come from intense observations of nature, dreams and recollections of personal experiences. "My current work grows out of an appreciation for the Southwest environment. Out of the experience of scaling canyon walls to view ancient pictographs among plants and animals that poke and bite. Out of memories of my mother and grandmother washing clothes and making soap in large cast-iron caldrons. Out of the story of my great uncle who dug up a caldron filled with gold. And out of the realization that life is connected to magic," he says.

James Curley Watkins was born May 28, 1951, in Louisville, Kentucky. His mother soon divorced from his biological father, L. C. Watkins. She moved to Athens, Alabama, when her son was six weeks old to live with her parents, who were farmers. Remarried in 1952 to Nelson Simmons, Sr., also a farmer, Jeanette Simmons delivered six more children. One son died at birth.

Watkins' mother observes, "Nelson Simmons was James' step-daddy. We never did use the word 'step' or 'half-brother' or 'half-sister.' That was never discussed. Nelson was just as good to James as he was to the other children."

"When I think back, I really had an idyllic life," Watkins says, "because we lived in town, but we also had the farm, which was five miles away. My mother refused to live on the farm because she had grown up on a farm

(previous page © Kippra D. Hopper) The Caprock in West Texas provides much inspiration in Watkins' work. The surfaces of his pots become landscapes themselves, as in the first photograph of a covered jar on p. 85.

A Meditation of Fire

Watkins helped his father on the family farm in Alabama. He developed his love of nature at an early age, having a creek and the woods to play in. (© James C. Watkins)

and didn't like the isolation of being a farmer's wife. But I had the privilege of two lifestyles. I had a social life with my friends in the city. And I had animals, the woods, a creek, and responsibility at the farm."

Watkins' mother and father both had their own personal sense of aesthetics. "My mother believed that the color of your clothes could influence your emotional state. She believed that red and orange would make you more alert and happy. My father believed that painting the house true green would ensure a good harvest," Watkins explains. "So we were six children—three girls and three boys—wearing brightly colored clothes, alert and happy, living in a green house. It was inevitable that one of the six of us would be interested in rituals and visual things."

When he became old enough, Watkins helped his father on the farm, raising cotton, corn, cows, and hogs. His father also cut trees on the farm for firewood and hauled coal from the coal mines to sell during the winter.

"While farming, I learned the pleasures of work, but only in retrospect. The greatest lesson I learned was to place importance on every stage, not to be anxious for the finished product, but to look and absorb the beauty of every phase," Watkins says.

On the farm Watkins also developed his ongoing affinity for animals and nature. Watkins, whose mother nicknamed him "Jippy" when he was young, remembers having an extraordinary relationship with his grandparents' dog, King. On many days he would take King for a walk in the woods on the edge of the Tennessee River, although his grandparents told him to stay close to the house. Years later, he told his mother that many times he would become terribly lost in the forest, but at his urging, King would lead him back home.

His mother tells another story about Ada, the mule: "Jippy and his younger brothers and sisters would ride the mule when they were very small. My husband had a big pond on the farm. The mule would take them out in the pond and just stand there. They would be so scared. They'd be trying to get the mule to come out of the water, but he'd just stand in the pond."

As a child, Watkins grew up hearing stories from his parents and grandparents—tales that have largely informed his work. "I've always been interested in making big bowls. I remember hearing the story of my great-uncle who was plowing a field in Athens, Alabama, and after he broke his plow, he went to the barn to get a pickax to dig up what he thought was a stump. Instead he dug up a caldron filled with gold, and he instantly became a wealthy man. He was able to hire many people to work on the large farm that he acquired. This was an amazing feat during the days of sharecropping," Watkins recounts.

The caldron image was part of a family ritual, as Watkins observed his mother and grandmother washing clothes and making soap in a cast-iron pot. "They would, at certain times of the year, boil the clothes and the bedding because they felt that was most sanitary and healthy," Watkins says. "They also made hominy, hogshead cheese, cracklings, and lye soap in the big pot."

Watkins' mother remembers, "We didn't have a washing machine until the 1950s. Before that we would boil the water in the wash pot; then we'd put the clothes in a tub and wash them with a rub board. It was hard

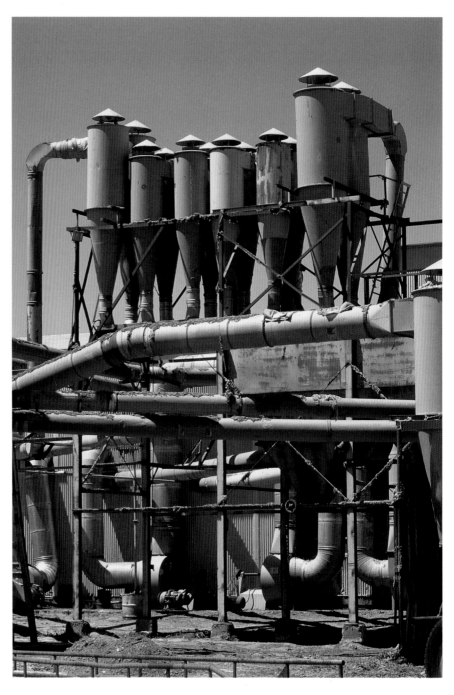

Cotton gin lint filters
are among the earliest structural
forms that influenced Watkins' work, as
seen for example, in the covered jar on p. 35.

A Meditation of Fire

work, very hard work. Even after we got a washing machine we still boiled the linens in the pot a couple of times each year to make sure they were good and clean."

Watkins' mother comments that she did not think her son was paying much attention to the work, although he helped put the wood around the pot, keeping the fire burning: "He never did complain about work."

For Watkins, the path toward a life's work in art began with drawing. Fascinated by portraits of his maternal great-grandmothers, Amanda Pride, called "Shug," and Mattie Weaver, Watkins, even at age three, would draw picture after picture. He remembers lying on the floor at the house of his grandparents, Ma Percy and Papa Henry, drawing on the backs of old calendars and record journals. He would study the portraits and try to understand perspective.

"When he started school, I didn't have much money," Watkins' mother says. "I would buy him a tablet, and every time he came in from school, I would look at his tablet. On every page he would have drawn cowboys, horses, and guns. I told him that he was using up too much paper and I couldn't buy him a tablet every day.

"Mama was there one day when I was fussing at him, and she told me to leave him alone, that he would be an artist one day. So she helped me buy his paper. All he would do in his spare time was draw. My mother kept encouraging me that he would be an artist, so I started encouraging him."

Watkins remembers other influences in his work from days on the farm, such as waiting with his father at the cotton gin. "I would be so bored that I would go to the glove compartment and take match book covers and draw on the inside of them. I would draw these cotton gin lint filters over and over again. And I forgot all about it until I moved to Lubbock and saw the same things again, with Lubbock being the cotton capital of the world. Then I started making pots that related in form to those filters," Watkins says.

When Watkins started school, his mother collected farmer's magazines with "Draw Me" advertisements for an art school contest, and she mailed in his completed images. When he was fifteen, he finally won a contest and started a correspondence course in art.

"My parents were sensitive to my art interests and were always supportive. I drew whatever images the ads asked for and my mother would critique them. She didn't know anything about art, but she would tell me if the eyes were too close together or the head was too big, and that it always needed to be neater," Watkins says. "So this was a real ritual between us, and it went on from the first grade all the way up to the tenth grade. Even in those early years, I called this activity my work."

Watkins recalls coming home from school one day and seeing "an official looking stranger" in the living room with a briefcase and a portfolio. Watkins thought he had done something wrong and was about to be punished. Instead, the man opened the portfolio and showed him all the drawings he had done over the years. Watkins then began a correspondence course through the Art Instructional School, which he completed when he was eighteen.

"The supplies cost $20 a month, and back then, that was a lot of money for a farming family," Watkins' mother says. "But my husband had some rental houses, and he gave me the rent from one of the houses to cover the cost."

Watkins remembers the school sending him a booklet each month. He would do the exercises in it, then mail his drawings to his instructor. The instructor would put tracing paper on top of the drawings, critique them, assign a grade, and mail them back. Watkins continued the course from tenth through twelfth grades.

At that time during high school, Watkins ran track and played football, and he received a trial scholarship in football to a local university. "However, that was in the 1960s, at the height of the peace movement and the nonviolence urged by Martin Luther King, Jr. I questioned whether I wanted to be involved in a violent sport. So I didn't try for the scholarship, but instead I enrolled at a local junior college to study design, drawing, and the usual academics," he says.

Thomas Brown was Watkins' art teacher at Trinity High School in Athens. "He was a big influence on me because I grew up in rural Alabama with no cultural outlets, and he was the only artist I knew," Watkins remembers.

"Our art class was in a poor, segregated school, with no art funds. It was mainly a study hall. We didn't have anything to really work with, but Mr. Brown created this little culture club for kids, and we would go over to his house and listen to jazz, play chess, and talk. He was a painter and a sculptor."

Brown also had been enrolled in an art correspondence course from the "Draw Me" ads when he was younger. "I saw myself in James," Brown says. "But he had more help than I had. I saw him being way ahead of where I was at age fourteen or fifteen. He would come to me often to show me some of the drawings he had done, and I'd look at them and talk to him about them.

"Something else that struck me was that James was always tall, even as a youngster. He was really charismatic because of his persona that went with that physique," Brown says. "He had a very humble, quiet persona, and he never even walked in a boastful way. He seemed to be one of those children who are raised by their grandparents. That was sort of a psychological evaluation that teachers used to make about kids. Those who were raised by their grandparents had more respect for people."

With the urging of his parents and Brown, Watkins pursued a higher education. Watkins' mother and father wanted all of their children to have an education, something they did not receive. His mother explains, "I missed out on some good jobs because I didn't have a twelfth grade education. I didn't get to go to school when school started. We were on the farm, and they didn't believe in children leaving all the work to the parents. So we had to stay and pick cotton until November. Then, when the time came to start planting the cotton, we had to stop school and help handle the fertilizer and cottonseed, so I didn't get a good education.

"We told our children that we wanted them all to get an education. And we never did let them say they couldn't do something. We told them they could be anything they wanted to be and do anything they wanted to do, so all of our children received a college education."

Watkins believes his parents were responsible for his becoming an artist. "My parents suffered a lot when they were growing up. They were committed to making life better for their children. Because of them, I was able to focus on self-realization. I didn't have to worry about struggling for an existence or about making money. They were good providers and made sure we all stayed in school," he says.

Through her tenacity, his mother also was able to help Watkins obtain his first paying job after graduating from high school at a local grocery store. "It was in the late 1960s and it was hard for black youngsters in Alabama to get a job—at that time they weren't hiring too many black people in grocery stores. Across the street from the store was a laundromat that had a 'Whites Only' sign in the window," she says. "One day I went down to the A&P grocery store, and I was really nervous and scared to talk to this manager. But I asked if he would hire my son. I told him he needed money to help with college. The manager told me he'd think about it, but he never did call me back. So one morning I got up, said a prayer or two, and went down to talk to the store manager again. I told him my son would do a good job for him. The manager then hired James to sack groceries. He was the first black person hired at that store."

At Calhoun Junior College in Decator, Alabama, Watkins studied design and drawing, hoping to become a magazine illustrator. One day he passed a pottery class that met across the hall from one of his design classes, and he became captivated by the cooperative spirit in the studio.

"Everyone seemed to be having a great time. One day I went in and all the potter's wheels were taken. A friend of mine was working, and I told him I wanted to make a pot. He told me to go away, that I was bothering him. But we were real close, so I knew I probably could make him mad. I told him that making pots was easy, that anybody could do it, and he got upset. I bet him a dollar that I could make a pot the first time I tried. I was able to make a short, dumpy, ugly pot, and I was obsessed from that moment on," Watkins remembers.

He dropped a class and enrolled in the pottery course, taught by Paul Molesky. "During that time I had no thoughts about the future or of my purpose—I was in love. Making pots was all I wanted to do," he says, noting that the studio was closed on weekends, so he would leave the window cracked and later crawl through to make pots late at night. Molesky subsequently told Watkins that he had been watching him.

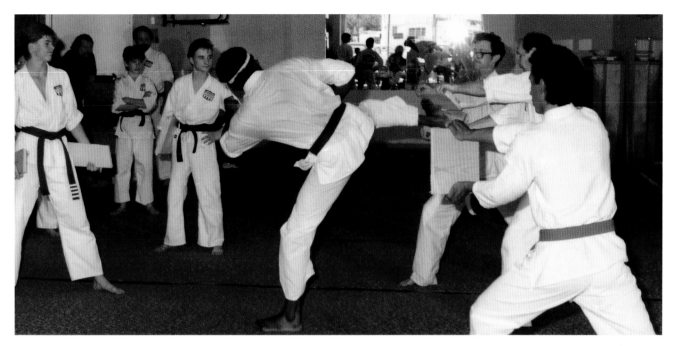

Watkins, who holds a black belt in tai kwon do, says the movements he has learned have influenced his bird forms as in *Knight/Night Bird,* a double-walled caldron on p. 122, that looks as if the form is ready to stir at any moment. (Courtesy James C. Watkins)

Enthusiastic about Watkins' interest, Molesky urged him to apply to the Kansas City Art Institute, where Molesky had received his undergraduate degree. He offered to take Watkins to KCAI during spring break, but Watkins' mother initially was apprehensive about letting him go. Watkins was eighteen years old and had never been alone in a large city.

"When James told me about going, I told him I wasn't sure he should go to Kansas City with white people. It was very different then. I told him I wanted to meet the teacher," Watkins' mother says. "I'll never forget that nice man. Mr. Molesky came to the house, and he was sort of a hippie who had this long hair. That kind of got to me again. But he was so nice. I remember popping popcorn, and he just sat there and ate popcorn like he was one of the family. That made me feel real good. So I told James to go ahead."

Molesky recalls meeting Watkins' mother and father. "His mother didn't know if she should let him go, whether she could trust me or not," he says. "I'll always remember walking in and realizing what a wonderful person his mother was, and I could see that same sort of personality, that same warmth in James. I thought, 'Oh my god, this woman did her job right.' I hoped that he could carry that on to become a decent artist."

Watkins worked hard to put together a portfolio of his work, including artwork from high school and the one year he had at Calhoun. Molesky reflects, "I remember James sitting and throwing. He had these great big, long fingers and wide hands, and he could throw these small, thin, little cylinders. That amazed me. And it intrigued me that he had that very gentle, delicate touch that enabled him to pull the clay up. I'd say within a week he was making halfway decent cylinders."

Molesky introduced Watkins to Ken Ferguson, a well-known ceramist at KCAI. "Ferguson was a very imposing person, but I was so naive that I didn't know anything about him or the prestige of KCAI. When Paul introduced me to him, I was kind of cocky and confident, and I think he liked that," Watkins says.

Watkins was offered a scholarship and a job mixing clay for the ceramics department, but even though he was accepted, he was fearful of leaving his home in Alabama.

"After Paul took me to Kansas City, I came home and started getting scared. I had seen all those artists and they were all scholarship material. They were from all over the world, most of them were very rich. And I was just a poor country boy from Alabama. I hadn't been anywhere. I was backing out," Watkins says.

"I went over to Paul's house one night, and this hippie, Polish guy from New York state said to me—and this was 1969—'James if you don't go, you're just going to be another black casualty in Alabama.' And I got so mad at him. It shook me to the bone," Watkins remembers. "But it made me realize that this was the opportunity of a lifetime, and if I didn't accept this, then what he said basically would be true. The war in Vietnam was going on, and I had friends that died there or came back all screwed up. When I look back now, a large percentage of my friends are alcoholics, drug addicts, imprisoned, or dead. So Paul possibly saved my life."

Watkins mixed clay for the department for three years and says he learned everything he knows about clay from that experience. Although Ferguson mentored him, Watkins says he remained fearful that he would not be able to succeed, and he kept in mind that his mother taught him to always have enough money to get back home from wherever he was.

"In my first critique with Ferguson, he just tore me up. And the next time I had a critique, I could see my heart jumping through my shirt. I thought I was going to have a heart attack. I kept my fare home under my mattress for a whole year because I was so afraid I wouldn't make it," he says.

At the Kansas City Art Institute, Watkins learned from Ferguson, Victor Babu, Jackie Rice, and George Timock to make good, functional pots. He calls the years at KCAI, from 1970 through 1973, the most exciting and energetic of his life, being surrounded by exceptional artists, instructors as well as other students. "There was no middle ground—only extremes. The faculty's influence and commitment to their work were contagious," he says.

Watkins recalls that he dealt with the pressures of art school through music. "There was a lot of competition. There were people who left the studio screaming, and we'd never see them again. During the really intense times, I would go home and listen to two songs in particular: 'Acknowledgment,' from the album *A Love Supreme* by John Coltrane, and 'Message from the Nile,' from the album *Extensions* by McCoy Tyner. The music

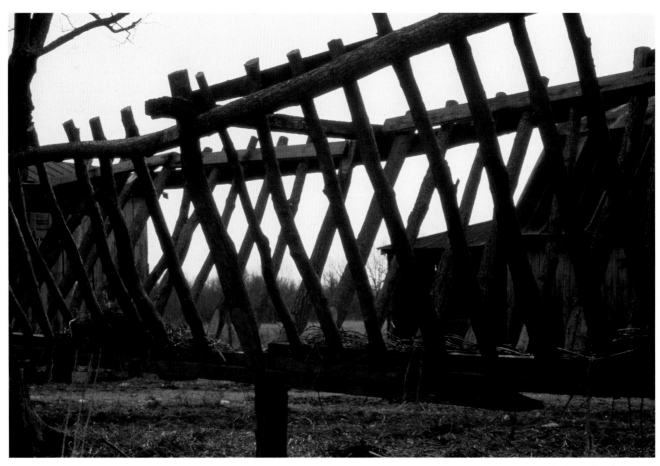

Watkins' father built a cow feeder with tree limbs on the farm in Alabama. The structure impressed the artist as it reveals the illusion of movement as one walks around it. The same interaction of the negative spaces can be seen in *Communion*, a double-walled caldron on p. 77. (© James C. Watkins)

would soothe me. I think it was life-changing for me because it reduced the pressure and gave me courage. I went back to the studio feeling good and rejuvenated."

Watkins marvels today at the large number of students in his graduating class at KCAI who now are working professionally with clay. Molesky comments that any person accepted at KCAI is among a rare breed because the faculty are so selective and choose only the most outstanding students.

One of Watkins' peers at Kansas City, ceramic artist Kurt Weiser, an associate professor at Arizona State University in Tempe, remembers Watkins as being a quiet student. "A lot of us were kind of loud, and we were all very competitive. James, on the other hand, seemed to be less obtrusive, I guess, than the rest. He worked as hard as everybody else did, but he just wasn't as obnoxious. Everybody there was involved in sort of a territorial battle about who was going to fill the kiln with pots. I don't ever remember James being too involved in that battle."

Watkins came home proud after earning his bachelor of fine arts degree from KCAI. "I was on the farm with my father, and he had built a cow feeder that the cows could stick their heads in and eat hay. I raved about how wonderful I thought it was. I thought his feeder had strong sculptural qualities, and I started talking about the spatial relationships and the linear qualities of the structure. The poles crisscrossed diagonally, and it had movement as you walked around it. My father looked at me, shook his head and thought it was crazy that I considered his cow feeder to be art."

Ferguson arranged for Watkins to continue his education at Indiana University in Bloomington. Watkins followed Ferguson's advice with complete trust, beginning his post-graduate studies with John Goodheart and the late Karl Martz. Watkins says his strongest memory of Ferguson was in 1973 when Ferguson called Watkins into his office and told him he wanted him to go to Indiana University.

"I replied, 'Yes sir.' I went to graduate school at IU and never applied to any other school. It was the right place for me," Watkins says. "It wasn't until years later when I became a teacher that I realized how special it was that my trust in Ferguson was so great. I never thought of doing anything other than what he felt was best for me."

Watkins' studies at Indiana University eventually would begin a time of questioning everything he previously had learned. "I felt that my work was only a visual regurgitation of principles borrowed from very influential instructors," Watkins explains. "So I started a conscious program to unlearn all that I had learned. I did everything I was told not to do. My work became more transitory, more concerned with experiences."

After spending his first year in graduate school working with conceptual concerns, Watkins returned to making vessels. He also became interested in reading everything he could find about dreams, learning about the Senoi people in Malaysia, who teach themselves and their children through autosuggestion how to remember their dreams and become conscious while dreaming.

Being concerned with dreams was not new to Watkins. His mother also was interested in dreams, and she often talked about them as he was growing up.

"A lot of my dreams have come true, and I've told James that dreams are very important. If they stay with you day after day, then they mean something," Watkins' mother says, recalling that her own mother, as well, believed in the power of dreams.

"I remember my mother, she was the same way, and her dreams came true. My mother dreamed one night that my brother, who also was named James, got killed. She jumped up out of bed the next morning while my sister and I were getting ready to go to school, and told us that our brother was dead. About fifteen minutes later, there was a knock at the door and a man told us that our brother had been killed in a car accident," Watkins' mother says.

Watkins recalls hearing that particular dream story when he was a child. "In graduate school I started practicing lucid dreaming, and of course it doesn't happen every night, but when it does happen, it's wonderful," he says. "You can touch objects and look at things that are very similar to objects you see in the awakened

state. I keep a journal next to my bed, and I'll either write down the dreams or draw them. A lot of the pot forms have come from the dreams."

Watkins centered his master's thesis show around his dream journal. He documented his dreams and then created objects based on those visions. In his exhibition, he showed his journal, drawings and pots. "In the last year of the three-year program, my work became more personal and secure," he reflects. "I could recognize that which was me, and I could visualize that which I wanted to be."

After his first year at KCAI, Watkins married Abbie Coleman, whom he dated in high school. After five years, the marriage ended amicably and without children. In 1974, Watkins met his present wife, Sara Waters, and her five-year-old son, Eric Rogers, at Indiana University. Waters, a single mother, also was a graduate student in ceramics. They were married four years later. Watkins said he immediately noticed Waters, thinking he recognized her from his past.

On the first day of class, Watkins and Waters both chose the same number in random studio selections. They decided to build a partition to divide the studio space.

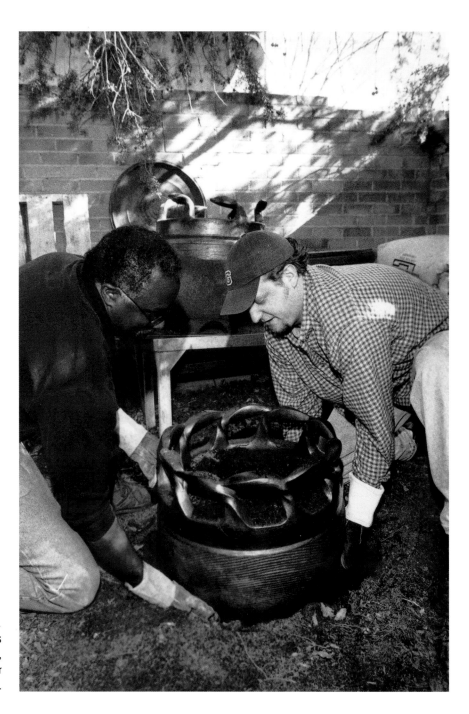

Watkins and his stepson Eric Rogers pull a double-walled caldron, *Communion*, out of a hole in the ground after the piece has been fired. The pot was placed in a chamber, covered with sawdust and allowed to smolder overnight, creating a blackened, carbon surface.

"We built the wall and didn't have quite enough wood and plaster board to cover all of it, so there was a two-foot division at the top. We couldn't see each other, but we could talk to one another. We practiced our presentations with each other, trying to build confidence in ourselves," Watkins remembers. "We became real good friends. Then we cut a small hole to pass back and forth our writings and books. We offered suggestions to one another. We became closer and closer, until finally, we cut a larger door in the wall so we could visit each other."

Because personal experiences are manifest in Watkins' art, he often refers to a near-drowning incident in which Waters saved him as providing many of his foremost insights. In 1977, Waters and Watkins were swimming in a small lake reservoir at Lake Griffith in Bloomington, Indiana. Waters was a strong swimmer and a former lifeguard, and Watkins says he thought he was a good swimmer, too. But halfway across, Watkins' whole body cramped, and he began to drown.

"I had this incredible experience. I don't remember any pain at all. I was not afraid. It was total acceptance. My life flashed before me, as if I were looking at a movie screen with images moving from left to right. It was only a matter of minutes, but it was as if I were being taught a lesson that life was beautiful and wonderful, and I was taking it for granted," Watkins says. "I saw all the missed opportunities I'd had with people I loved and hadn't expressed myself to. I saw the missed opportunities I had to be more human and more loving. I laughed under the water at how stupid I had been in not realizing that life was wonderful, precious, and a gift.

"Sara came back and pulled me out of the water. After that, food tasted better, colors were brighter, music sounded better. It was incredible."

After Waters and Watkins finished their master's of fine arts degrees in 1977, Waters accepted a position as a professor in the art department at Texas Tech University in Lubbock, while Watkins took a one-semester position in the art department at Hampton University in Virginia. Watkins was a sabbatical replacement for Joseph Wades Gilliard, who had started the ceramics program at Hampton in 1935.

The Hampton campus overlooks Chesapeake Bay, and Watkins took his drawing classes outside to draw the boats. Watkins remembers being moved by the fact that the university's earliest students had made bricks by hand and built some of the campus buildings themselves.

The university was founded in 1868 by Brigadier General Samuel Chapman Armstrong, a Union military commander of black troops during the Civil War. Initially, Hampton was built for those troops and their families. In 1876, American Indians also began attending the institute. In the late 1800s, disease took the lives of many of the American Indian students. Hampton University today maintains a significant collection of American Indian artifacts and art. The collection was of great interest to Watkins because his paternal great-grandmother was of American Indian ancestry. The objects later would influence his work.

After teaching the semester at Hampton, Watkins moved to Lubbock to be with Sara and Eric, intending to set up a home studio and introduce his work to the galleries of the Southwest. "I began working immediately, but with great difficulty. The Southwest environment was so different. My previous forms and colors didn't relate to this. The work didn't feel right. I stopped working and just started going out hiking and looking at the land and being quiet and listening. I wanted to absorb the beautiful surroundings," Watkins explains.

He began frequenting the canyons and desert lands of the region, not only to find visual stimulation, but to retrieve elements to use in his work. "I would dig up clays from dried up river beds and from the sides of canyons and in caves. I enjoyed bringing back clays and colorful rocks to my studio and finding out what they do. Everything does something. It adds an element of surprise. There's a kind of serendipity about it, discovering something new."

Watkins began to show his work, and he was asked by the Lubbock Parks and Recreation Department to organize a community-based pottery program. As the director and organizer of the Mackenzie Terrace Pottery Center in Lubbock, he taught clay to a diverse socioeconomic and ethnic group of people who shared the goal of making the most beautiful object of clay they could.

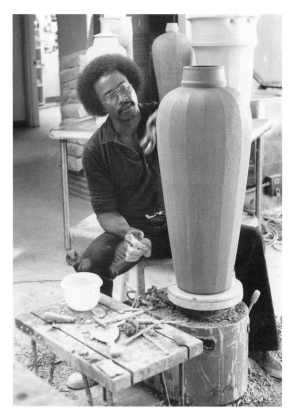

Watkins directed the Mackenzie Terrace Pottery Center in 1978.
(Courtesy James C. Watkins)

"In one class I had an autobody mechanic, a doctor, a short-order cook, a lawyer, a high school student, a teacher, Hispanic, black, white, Asian. It was amazing," he says. "The reward of being among such a diverse group of people was a feeling of accomplishment, friendship, and a strong sense of camaraderie."

The location was a sixty-year-old office building overlooking Mackenzie State Park. He designed an organizational structure for the center, acted as consultant in the renovation of the building, built the kilns, and ordered supplies and equipment.

"Teaching at the pottery center, I had to do a lot of experimenting with glazes because the students wanted a wide variety of glazes. I made lots of dinnerware and lots of functional pieces; I supplemented my income that way," says Watkins, explaining that he and Waters had garage sales, inviting people in to see their pottery. They earned enough money from sales of their art to make a down payment on their current home. He later added on to the house with his own studio and kiln and Waters' studio.

After serving as the center's director and one of its four instructors from 1978 to 1983, Watkins began teaching at Texas Tech University, where he is now a full professor in the College of Architecture, teaching all levels of architectural delineation. In 1990 he received the President's Excellence in Teaching Award from the university. During the same year, he also traveled to New York, England, and Paris to study contemporary studio architectural ceramics.

Watkins often remembered holding in his hands an ancient Japanese tea bowl in the basement of the Nelson-Atkins Museum in Kansas City while under the tutelage of Ken Ferguson. Finally in 1994, he was given the opportunity to spend three months in Japan, experiencing a culture considered to be a living museum and the melting pot of ceramic techniques of the world.

Selected from a pool of 1,664 applicants, Watkins was one of six crafts artists in the United States to be nominated by the National Endowment for the Arts to act as a U.S. Cultural Exchange Artist. Although he did not receive the NEA grant, he and Waters received faculty development leaves from Texas Tech University for their visit.

They both were Resident Artists at the Shigaraki Institute of Ceramic Studies in Shigaraki, Japan, and Resident Scholars at the Japan Center for Michigan Universities in Hikone, Japan. Watkins and his family used Hikone as a base and traveled throughout Japan, visiting museums, galleries, and the studios of Japanese potters.

"I've always appreciated Japanese pottery. Several of my instructors had gone to Japan and were influenced by the pottery. I always have been enthralled by the respect the Japanese have for pottery. Their culture embraces the creative act, and pottery is considered a high art form," Watkins observes.

From his travels to Japan, Watkins says his work has become more refined. He continues to learn the importance of savoring the time of working, embracing the act of creativity itself.

Since 1974, Watkins' work has been included in more than 120 solo and group exhibitions throughout the United States. He also has given more than fifty lectures and workshops throughout the country.

Watkins' work is shown internationally, and is included in the permanent collection of the Shigaraki Ceramic Cultural Park in Shigaraki, Japan, and in the first permanent White House Collection of American

Crafts. In 1995 his work was shown in two museums of the Smithsonian Institution—the Renwick Gallery, in the *Uncommon Beauty In Common Objects, The Legacy of African American Craft Art* exhibit, and the National Museum of American Art, in *The White House Collection of American Crafts* exhibit.

Watkins, with other artists from across the country, met in 1993 with the President and First Lady Hillary Rodham Clinton at the White House. Watkins' work was included in the prestigious White House collection, part of the *Year of American Craft: A Celebration of the Creative Works of the Hand,* as mandated by a presidential proclamation and a joint resolution of Congress.

The collection was first presented as an exhibition at the Smithsonian Institution's National Museum of American Art and then toured major museums throughout the United States. Following the tour, the collection will be displayed periodically at the Clinton Presidential Library and will be available for loan to museums throughout the country.

The year 1999 marks thirty years of Watkins' work with clay. Through the years, he has endeavored to keep himself and his work energetic. Toward that end, he recently began taking piano lessons. In his home Watkins is surrounded by music, and among his most cherished activities he is learning a favorite piece of music—a Celtic folk song titled "Are Ye Sleeping, Maggie?"—with his daughter accompanying him on the violin.

He recalls a drawing instructor at KCAI, Stanley Louis, who would ask his students to voice the sounds a particular work of art might have. "When we would talk about the composition of a drawing, he would ask, 'How does the eye move through the drawing and what sound does the drawing make?' It made me think about rhythm, music, intervals and time," Watkins says. "I've always carried that through all the work I do in ceramics."

"I think about the last thirty years, and I realize that all of my experiences and the people that have been a part of my life are the artifacts of my personal reality. They provide me with the impetus to continue working joyfully and with great enthusiasm."

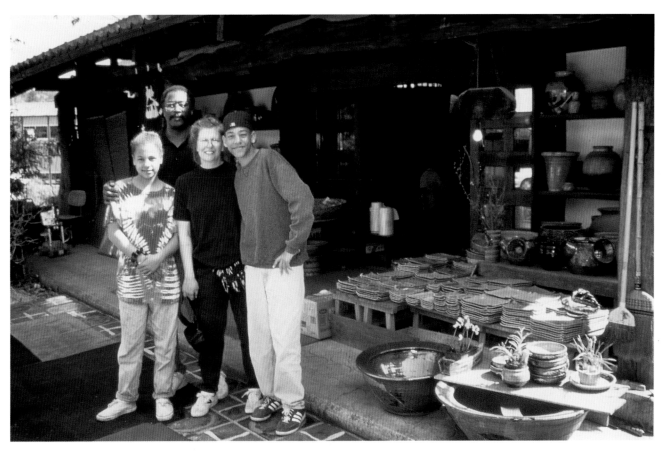

Watkins and his family visited Japan in 1994. Shown left to right are his daughter Tighe, Watkins, his wife Sara, and his son Zachary. (Courtesy James C. Watkins)

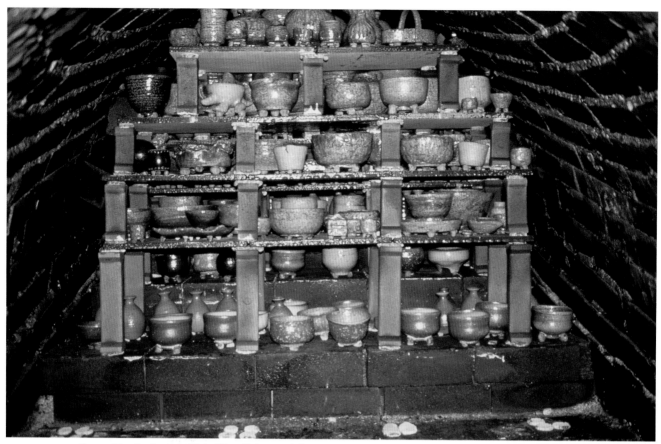

The wood-burning Anagama kiln in Shigaraki, Japan, took five days to fire and holds three of Watkins' pieces, all titled Tea Bowl. (© James C. Watkins)

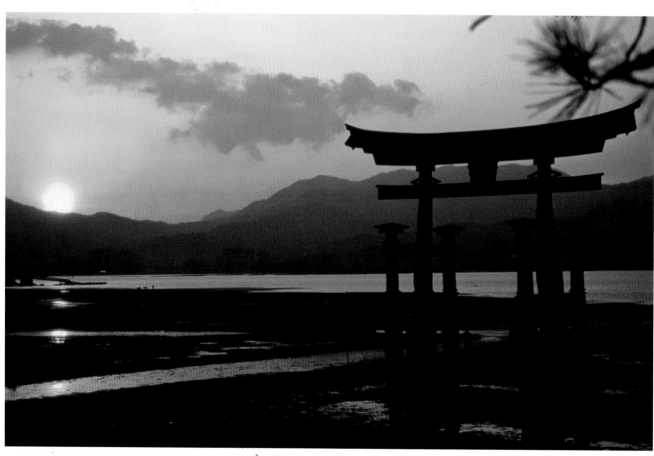

Watkins incorporates many of the images he saw in Japan into his work. For example, *Bird Basket* on p. 106 reveals the influence of the Shinto Torii structure, Miyajima, Japan. (© James C. Watkins)

A Meditation of Fire

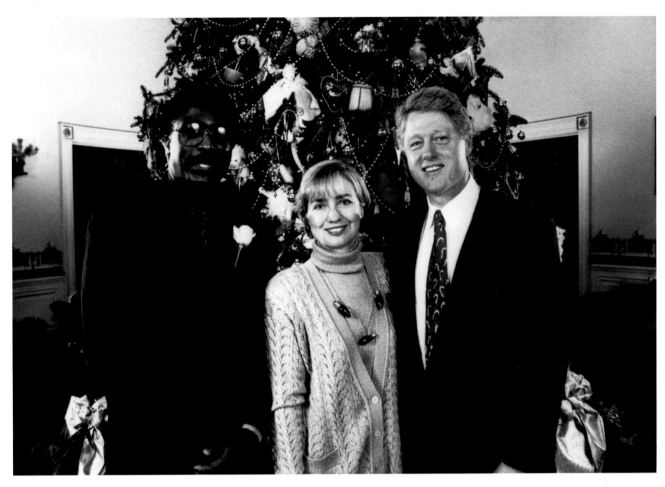

Watkins met the President and First Lady Hillary Rodham Clinton at the White House during a reception for the *White House Collection of American Crafts* exhibit in 1993.
(Courtesy James C. Watkins)

WITHDRAWN

SPRING CREEK CAMPUS

CREATION

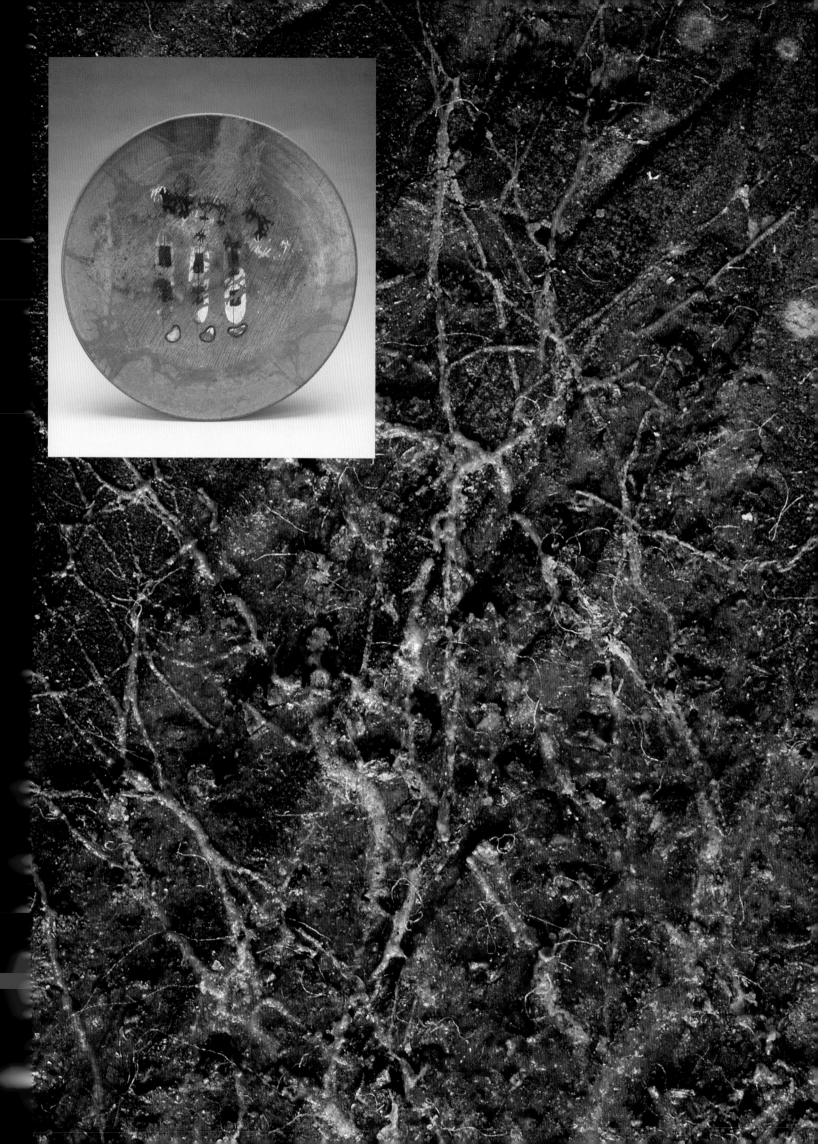

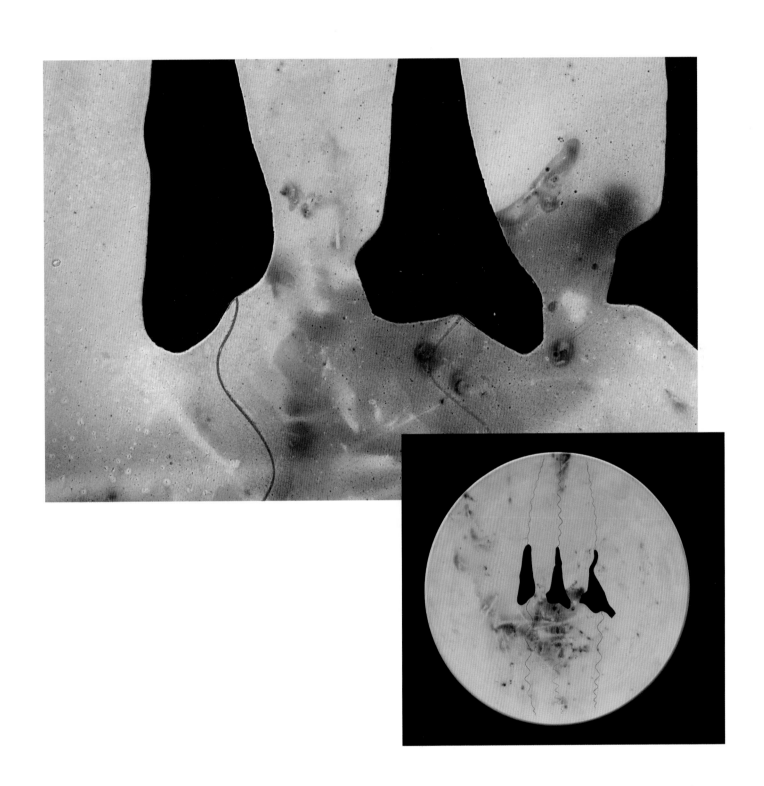

(above) From the *Number 3* series,
porcelain, 1979
(facing page) From the *Number 3* series,
earthenware, 1978

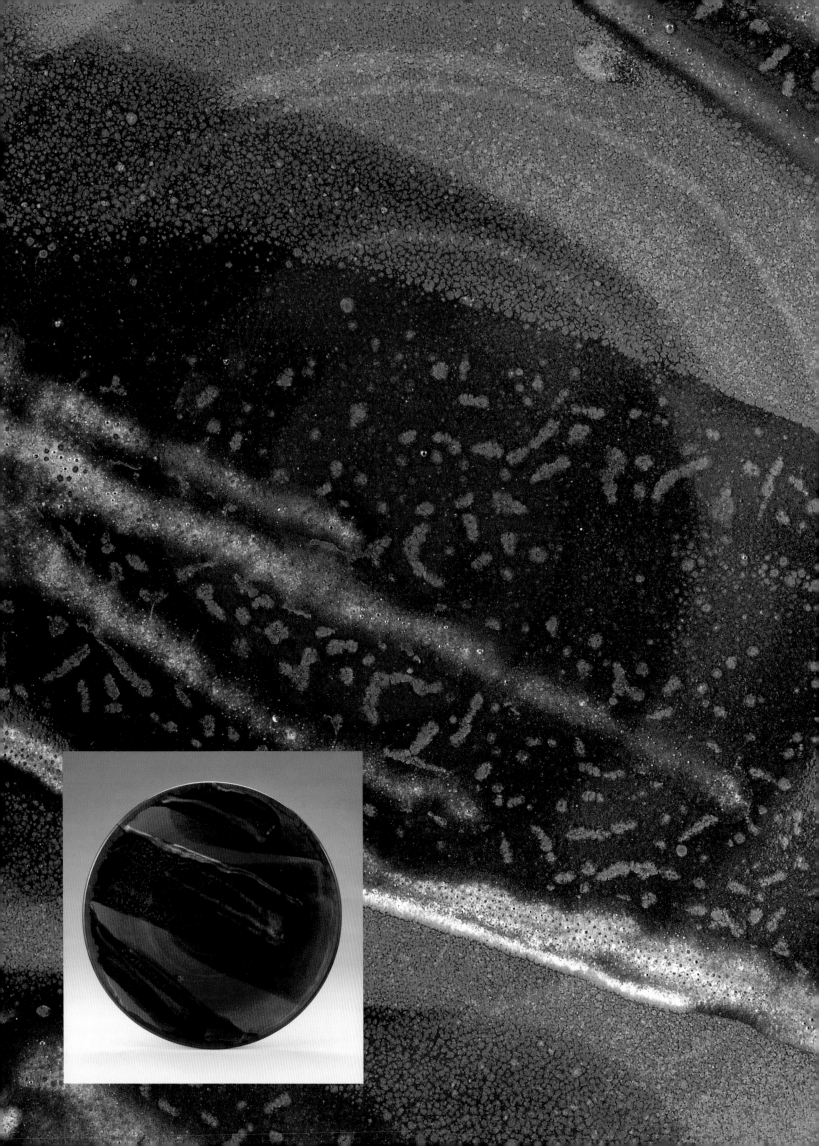

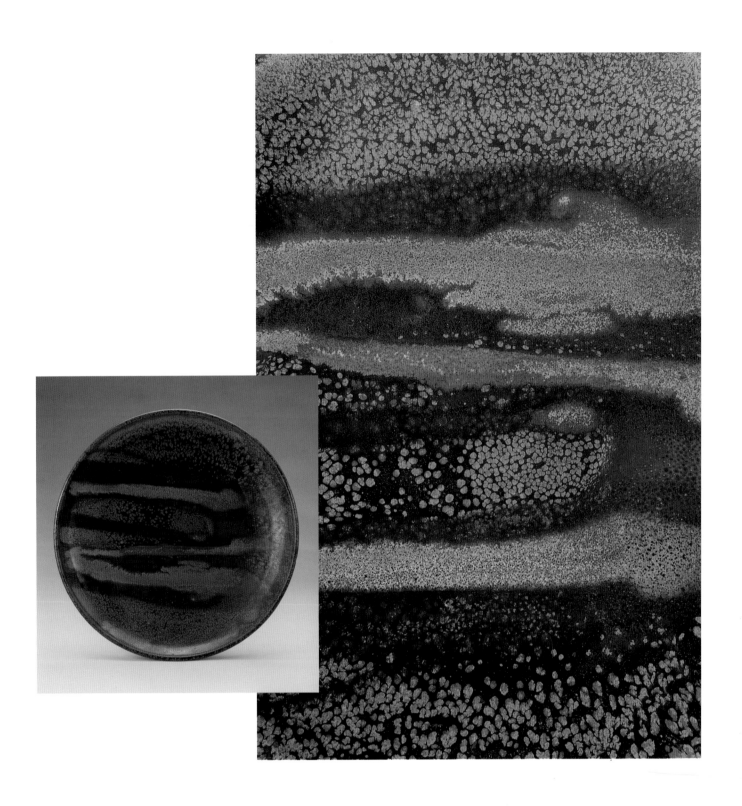

(above) Platter, stoneware, 1983

(facing page) Platter, stoneware, 1979

INSPIRATION 2

I believe a leaf of grass
is no less than the
journey-work of the stars.
–Walt Whitman

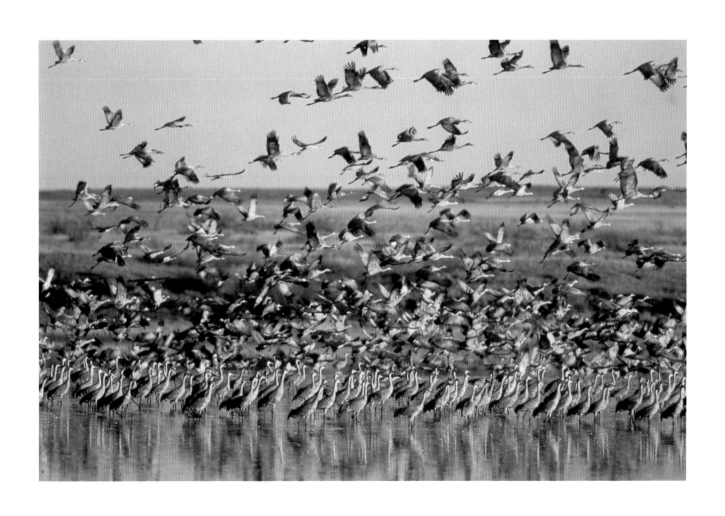

The coming of fall in West Texas is marked each year by the arrival of sandhill cranes and wintering waterfowl, most notably Canada geese. I wait each season for the first distinct shrills of the birds as they fly over my home. This conscious decision to remain alert places me in harmony with nature and her splendid phenomena—the yearly visitation of companions seeking sanctuary from the cold.

Making an annual pilgrimage to the Muleshoe Wildlife Refuge, we arrive an hour before dawn to observe the hundreds of birds who winter on the playas. The wind is chilly and howling, but we still hearken to the majestic sound of the flocks. The geese and cranes roost on the refuge lakes at night, then fly at sunrise to surrounding wheat fields where they feed during the day.

As the daylight brightens, a single bird raises its wings and launches itself upward, and remarkably, within seconds, dozens more follow. The horizon becomes dotted with hundreds of the birds flying in synchronicity, a harmonic din rising from their balanced formation.

Wintering sandhill cranes and geese come from their Alaskan and Canadian breeding grounds to stay for six months at Muleshoe, which has one of the largest concentrations of sandhill cranes in the world. For the migrating birds, the small basins of water along the central flyway provide havens of moisture and food on the semiarid plains. An estimated 25,000 such playas in Texas, New Mexico, Colorado, Oklahoma, and Kansas are utilized by 600,000 to more than 3,000,000 birds each year.

Sharing the prairie land, scattered with mesquite, are rattlesnakes, coyotes, bobcats, prairie dogs, badgers, skunks, porcupines, cottontail rabbits, and jackrabbits. This haven is a tangible testament to the fact that nature prevails, insisting on the resiliency of life.

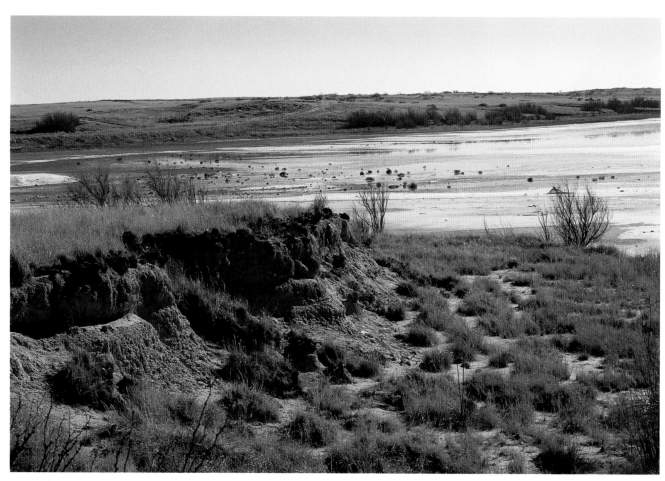

The Muleshoe Wildlife Refuge's playa lakes are home to Canada geese and sandhill cranes during the winter months. References to playa lakes and to the point at which earth and sky meet can be seen in such work as the double-walled caldron from the *Horizon* series on p. 94.

(previous page © Wyman Meinzer) The graceful necks of sandhill cranes have emerged as appendages on the rims of Watkins' caldrons and platter forms. The smoky gray color of the cranes also has appeared in his work, as in the double-walled bowl on p. 104.

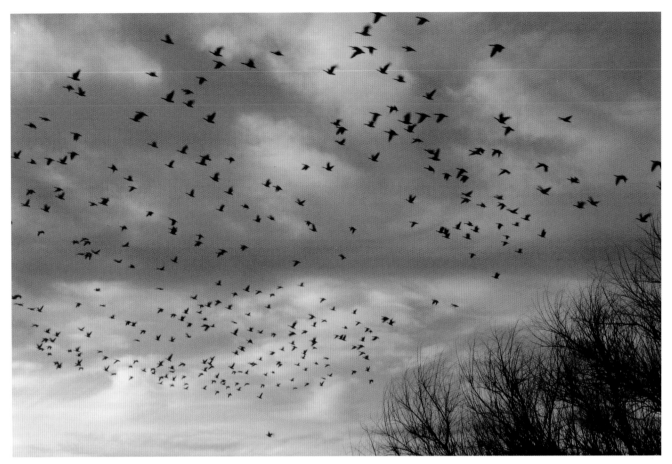

The coming of fall in West Texas is marked each year by the arrival of wintering waterfowl, such as these Canada geese. For Watkins, these wild animals awaken in him a sense of being in a world of nature. (© Kippra D. Hopper)

The divine, skyward travelers have emerged as the main imagery in the pots of James Watkins. The birds are akin to spirits that haunt the open land, bringing with them winged tidings that time is passing. We, too, find our own refuge in those creatures and places wild and free.

In all its promise, nature informs the work of James Watkins. He discovers a unity between himself and the environment as he explores the enchantment of the Southwest.

"I approach my work with a sensitive, responsive attitude—being sensitive to the visual stimuli of the desert and canyons, as well as to the internal visions of marks, lines, and movement, then responding in an appropriate way," he says. "I think that no matter where I live, there will be influence from the environment. In my work, I try to absorb everything that's around me."

Watkins' affinity for the Canada geese and sandhill cranes emerged the first year he was in West Texas. "I saw wild turkeys, Canada geese, and sandhill cranes on the drive from Virginia to Lubbock. I had never seen those things in my entire life, and it was just fascinating to me. I was blown away to find out that seeing these wild animals was very common," he says. "They've been in my world ever since, and eventually, I had to do something with that influence."

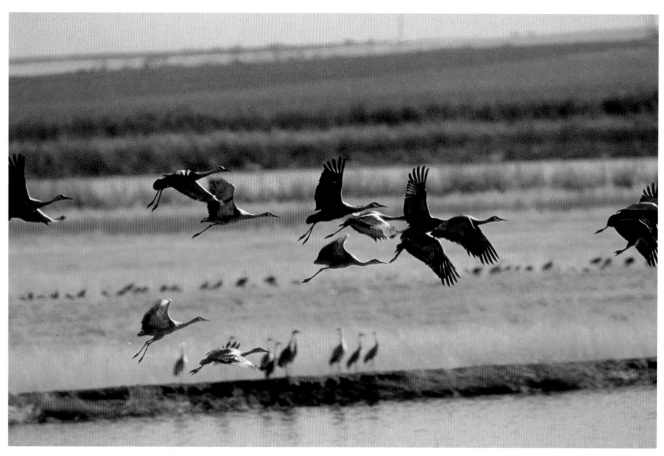

The stretching movements of sandhill cranes can be seen in the bird appendages of Watkins' work, which offer a sense of flight, as in *Bird Basket,* a double-walled caldron on p. 114. (© Wyman Meinzer)

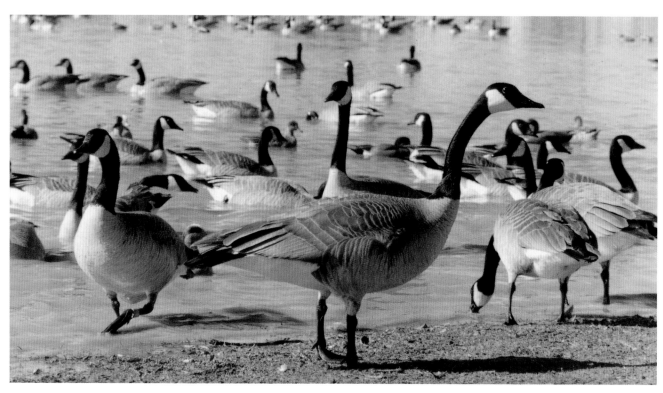

Watkins finds inspiration in the curves of the necks and the shapes of the heads of Canada geese, adding these forms to the rims of his pots and platters, as in the double-walled bowl on p. 104. (© Kippra D. Hopper)

A Meditation of Fire

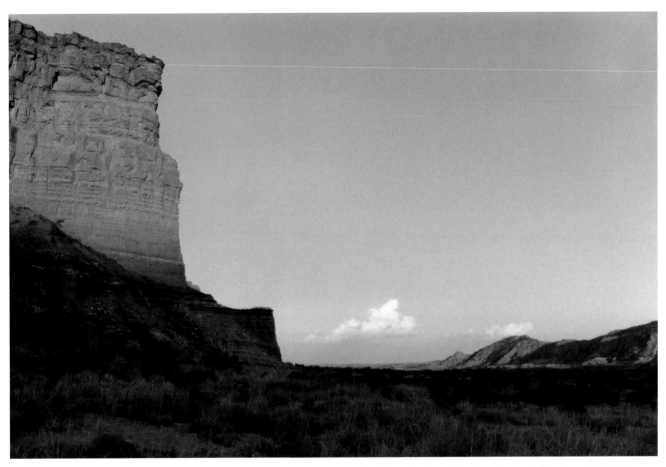

The sun rises at South Prong in Caprock Canyons. The orange of the bluff and the blue of the sky can be seen in the colors of Watkins' pieces, as in the platter form from the *Painted Desert* series on p. 95. (© Kippra D. Hopper)

Watkins often digs up clay from dried up river beds in the canyons to make slip glazes, as he did with the platter form in the first photograph on p. 95. (©Kippra D. Hopper)

INSPIRATION

When he first moved to Lubbock, Watkins was greatly impressed with the West Texas dust storms. He often collects the dust to make terra sigillata (liquified, decanted clay) that he uses as a slip glaze. The dust creates the deep orange and brown color, as in the platter form on p. 81. (©James C. Watkins)

Watkins began adding bird forms as appendages to the rims of his huge, double-walled caldrons. Being inspired by the forms of rocks, shells, fossils, and seed pods, Watkins also adds shapes of other organic elements to his pots and platters. Additionally, he creates drawings of the birds on the surfaces of his pieces.

"I am using animal and architectonic forms with a subtle suggestion of movement. To me, the appendages make the pots more exciting to interact with, and the pots become more sculptural in the way space is dealt with. I want the forms to conjure up a primal instinct for ritual display and ceremonial posturing," he says.

Watkins, who holds a black belt in tai kwondo, says the movements he has learned have influenced his bird forms. "The movements in the martial arts are like dances and that has influenced the shapes in their torque. The idea is to have the pot look as if it has the ability to move. I am trying to capture that frozen tension and subtle movement. They look as if they could snap back and move any minute."

In observing nature, Watkins often visits the region's canyons, caves, and desert lands for visual catalysts as well as for local materials to use in his work. Bringing images, clays, and colorful rocks back to his studio, Watkins remarks that ceramic art is similar to alchemy because a person can transform something very common into something precious, and often unanticipated.

"Everywhere I go I always bring back something. It could be just a rock or clays that I dig up from dried up river beds and from the sides of canyons. I've gone into caves and collected minerals that make various colors in glazes. I'm influenced by the bumpy, licky, oozy, yummy textures, and by the shapes of stalactites and stalagmites in caves. I experiment with the materials based on the concept that everything results in some unique effect," he says.

"Many times when I'm working with clay, I'll have an idea about what I want the glaze or the surface to look like, but the fire will do something unexpected. It can be beyond my own sensibilities. I'll look at it and wonder how such effects happened. Clay is very inventive and always has an element of discovery and serendipity."

A Meditation of Fire

West Texas' weather, including its tornadoes, influences the forms and surfaces of Watkins' work. The platter forms from the *Number 3* series on p. 82 both show such atmospheric images. (© Courtesy of the Southwest Collection)

From the West Texas landscape—including its weather—Watkins discovers ideas for both the forms and surfaces of his works. When he first moved to Lubbock, he was overwhelmed by the land's vastness, flatness, and abrupt gorges. "Linear elements were everywhere—barbed wire fences, cultivated cotton fields, and grain elevators. So I started making pots that were very linear and related to the straight roads, fields and fences. But the most awe-inspiring phenomena of all were the dust storms. I began to gather dust after these storms to make terra sigillata (liquified, decanted clay) that I use as a slip glaze."

Most popular artists have reflected their environment in their work, comments Ruth Butler, editor of *Ceramics Monthly,* the premier publication for the ceramic arts. Watkins was featured on the cover of *Ceramics Monthly* in 1992 when he authored an article about his work, titled "Pots Made of Memories."

"The first time I saw his work, I was impressed with the scale and strength of it. I also appreciated his surfaces and his incorporation of local materials and the influence that his environment has had on his work," Butler says. "As a ceramics person myself, I value the fact that James has seen what can be done with the materials he has gathered in his own environment in an area that is not necessarily known for its claywork. Traditionally in Japan, the various styles that are so well-known around the world—for example, Shigaraki clay—reflect the local environment and the materials that are there."

Responding to the environment, Watkins searches for a balance in his work between material and texture, color and form. Concerned with creating a visual equilibrium made up of contrasts, Watkins says he develops a rhythm, a beat, a sound, and intervals of highs and lows, shorts and longs—as in music—through visual texture, tactile texture, and layering.

"It's like a juggling act with ideas about drawing and sculpture coming together," he says. "The pots have visual texture with the drawings and the glazed surfaces. They have tactile texture with the raised and smooth surfaces, shavings, scratches, and sandblasting. The contrast of values and colors creates layers. I want the

surfaces to look as if they grew out of nature, to be organic and alive. The colors are those one can see in the skies and land of this region. I'm juggling all these aspects to create a form that looks balanced, although it's not symmetrical. For me, that's a real challenge. The textures and layering make people interact more with the pieces. I can look at some of my work and never really absorb all that is there."

The drawings on the pieces are a way of repeating the three-dimensional image in a two-dimensional form, he says, explaining that he is making a connection between the exterior and the interior of the work. Watkins produces yet another aspect of visual depth with his double-walled forms—an interior space unseen between the walls.

"The space exemplifies stored energy, mystery, and a symbol of the vessel as a contained container. The walls become analogous to skin—a clay skin asking to be touched," he says.

Called "monumental" and "haunting," Watkins' works are often large as he is fascinated by being able to control a great amount of clay, twenty-eight pounds alone for the platters. The double-walled caldrons weigh about sixty pounds after they have been fired. In a *San Antonio Light* article, Ric Collier, former director of the Southwest Craft Center, observes, "I don't look on Watkins' works as bowls and platters. They are sculptural pieces. But they are sort of about Watkins, too, because they are so large and the expanse is so unreasonable."[1]

Watkins replies: "Yes, I'm six foot, two inches tall and have large hands, but my size doesn't have a lot to do with the forms. They are made with a technique of throwing the pot to a certain height, letting the clay stiffen, then adding more clay and pulling up an additional height. Theoretically, you can make the pot as tall as you want. This is an ancient coil technique that cultures throughout the world have used."

In another reference to the proportions of his work, art critic Janet Tyson of the *Fort Worth Star-Telegram* describes Watkins' technique of joining an inner wall and an outer wall in his caldrons, which appear to have sides that are five inches thick. "Not to dwell on technique, but it's important to understand the extent to which Watkins deals with illusion in his work," Tyson writes. "He attempts—successfully—to evoke a form on a mythic scale. His stumpy, mortar-like vessels seem fit for a race of giants, and, as this series of pots is an homage to ancient American Indian tribes of West Texas, that seems quite appropriate."[2]

Although most of his work results in those massive and assertive pieces, Watkins says one of his favorite pots is a small composition that sits on the fireplace mantel at his home. He is in wonderment over the colors, the depth of the smoking, and the texture of the pot, which was

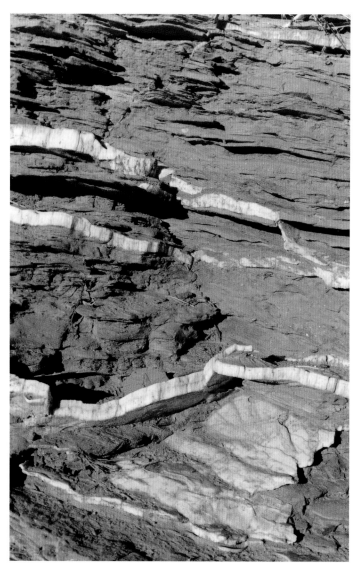

Strata of gypsum and sandstone are a prominent feature along the creeks of the canyons of West Texas. After seeing these layers of rocks, Watkins began sandblasting the surfaces of his caldrons to obtain a sandstone effect, as in the double-walled caldron from the *Rattlesnake Canyon* series on p. 44. (© Kippra D. Hopper)

pit fired in an experimental kiln firing at the Texas Tech University Center in Junction where he teaches each summer.

"As a sentient being, I am trying to make vessels that appeal to all my senses. What is important to me is to create forms that radiate strength, stability, and sensuality. I want my vessels to appear both masculine and feminine, voluminous, and voluptuous. I want them to suggest a duality of relaxation and explosiveness, where opposites coexist to create a dynamic tension," he explains.

"Throughout my work, there are undertones of decisions based on whimsy. Each piece is comprised of preserved memories from both a personal and a borrowed history. They become artifacts of a personal reality. It is not important that this be recognized or understood by the viewer."

Collectors and observers of Watkins' work comment that he is both an excellent craftsperson as well as a gifted artist. "James' work is something that becomes strong by embodying both expression and the treatment of materials as primary concerns," remarks Joshua Green, director of ceramic art at the Manchester Craftsmen's Guild in Pittsburgh, Pennsylvania. "To me, the double-walled caldron pieces take on a high level of control and deliberateness, both in terms of the construction of the pieces and in the firing process. The combination of pit firing and saggar firing is a process that is about giving up control, but James has become articulate with the process. He really has tremendous command over blackening the color through smoke. He is involved in the pursuit of mastery over the technique. So while it might be magic, it's magic that manifests itself the way it does because he has become so highly skilled with it."

Artist Gail Kendall, a professor of ceramics at the University of Nebraska at Lincoln, suggests that Watkins' work is precise and meticulous, adding that his large, double-walled caldrons are technically amazing.

"To throw one of these vessels and to get through the process without having it crack is difficult and beyond the means of most potters' abilities," she says. "The Raku firing process is prone to huge thermal shocks. James' work represents a really high level of the Raku technology."

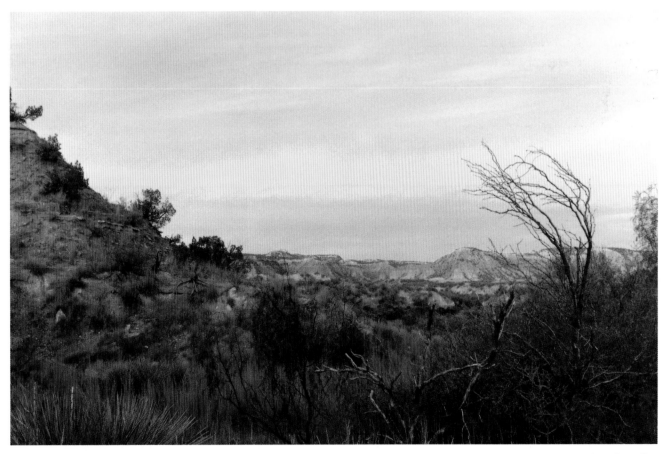

In Caprock Canyons, we are aware of eternity as we view ancient rock outcroppings. The colors of the sky have had an effect on the colors Watkins seeks in the surfaces of his work, as in the pink and orange in *Sleeping Posture* on p. 116 and in the blue in the double-walled caldron from the *Guardian* series on p. 122. (© Kippra D. Hopper)

Technically, Watkins' pieces are beyond reproach in the opinion of Winnie Owens-Hart, artist and ceramics professor at Howard University in Washington, D.C. "James has merged both talent and technique. His work certainly has refinement, splendor and just a quiet power," she says. "I'm always doing architectural comparisons, and as grand as it is, his work doesn't overwhelm you. James deals with the surface treatment, the volumetric aspects, the colors and form in a total package."

Watkins emphasizes the significance of touch through the entire ceramics process, Green says, noting that Watkins' creation of contrast between the matte surface and the softer surface on his caldrons is appealing as a combination embodied on the same piece.

"The blackened pots carry through the metaphor of an actual caldron. It looks like something that could have been used as opposed to the fire in which it was fired to make the object. In another sense, the contrast between the matte surface and the eggshell or skim-like surface that comes from the terra sigillata slip is appealing because the terra sigillata alludes to something that's been handled a lot or polished by touch," Green observes.

Watkins remarks that the contrast gives his pieces a visual edge, and that often he creates hidden images through colors and contrasts. "I want people to investigate the work. Different surfaces have different visual weights. In creating the textural and smooth surfaces, I'm thinking about the symbolism of earth and sky, a horizon, on the pots."

Collector Tom Turnquist of Lakewood, Colorado, explains that Watkins' work appeals to him because the surface treatment perfectly matches the form of each piece. Turnquist has been collecting American pottery for twenty years and has six pre-caldron pots of Watkins' in his collection of about 700 works.

"I like well-executed, well thought-out, consistent vessels. The pieces I have of James' work are very straightforward, very classic work. They exhibit a lot of integrity from a potter at that moment in time doing traditional forms or vessel versus sculpture. To me the sign of a good piece is that the glaze fits the size or volume of the piece," he says.

Impressed with Watkins' surface treatment of his work, Vicki Meek, director of the South Dallas Cultural Center, comments, "For me, the most defining element of what James is doing is the care with which he deals with the glazes and the images he creates on the surfaces. I'm in love with his work. It's really a melding of three-dimensional form and painting with the glazes. He creates three-dimensional paintings."

Meek curated a show in 1995 at the African American Museum in Dallas that included Watkins' work as a representation of the emergence of the vessel into sculptural form. "James is working in a very traditional art form, as far as vessel making is concerned, but he's really taken the vessel many steps beyond the point of pure utilitarianism," she notes. "Traditional African art vessels were always sculptural, and oftentimes they were in abstracted forms of humans and animals. What he's doing with the vessel is a slightly different twist in that he certainly has modernized the notion of a sculptural vessel in the way he simplifies the forms and creates something totally his own."

Watkins' vessels are effective because of their scale, according to Richard Burkett, associate professor of ceramics at San Diego State University in California and coauthor of the sixth edition of *Ceramics: A Potter's Handbook*, which includes examples of Watkins' work.[3] "He has taken the bowl, which is the historical precedent to his caldron, and made it uniquely his own—made it more personal and contemporary. His forms are evocative of aspects of his life and things that are important to him. His pieces have a definite reference to the Southwest and Texas landscapes. There's both a sense of elegant and strong form and of vital content in where the work is coming from," he says.

Pottery is captivating as something to collect, Turnquist says, because the artist takes clay, one of the world's basic elements, and converts it into something magical, beautiful, and wonderful. "Another aspect I like is that there's something amazing about the fact that while I'm alive I can share space with an object that, because of its stability and the ability to withstand the stresses of time, could be around for another few thousand years."

Turnquist notes that what is most important to him in collecting are his relationships with the people who create the works. "James is a very ethical person, a very decent person. The most important part of collecting is what's gained from knowing these people and the friendships that are formed. I think the collector and the potter or artist feed off each other in a positive sense," he says.

Turnquist says he remembers Watkins mentioning to him that after twenty years in the state, he feels like a native Texan. "If I put James in the context of some of the other Texas studio potters that I am familiar with, he fits the mold well. I think Texas potters are less prone to follow the crowd. They are independent, seek their own level of work, and have less fear of experimenting."

Owens-Hart, a long-time friend of Watkins, echoes Turnquist's statement, adding that Watkins always searches for his own innovative creations. "He keeps asking. He doesn't stay in the same place. He keeps looking and investigating what's around the corner."

Notes

1. Quoted in Mary Lance, "Pots Made of Memories: Near-death Experience Turns Life into Magic." *San Antonio Light* (January 13, 1993).
2. Janet Tyson, "Four Artists Plus 1 Show Feats of Clay." *Fort Worth Star-Telegram* (February 25, 1990).
3. Richard Burkett and Glenn C. Nelson, *Ceramics: A Potter's Handbook,* 6th edition (Fort Worth: Harcourt, Brace, in press).

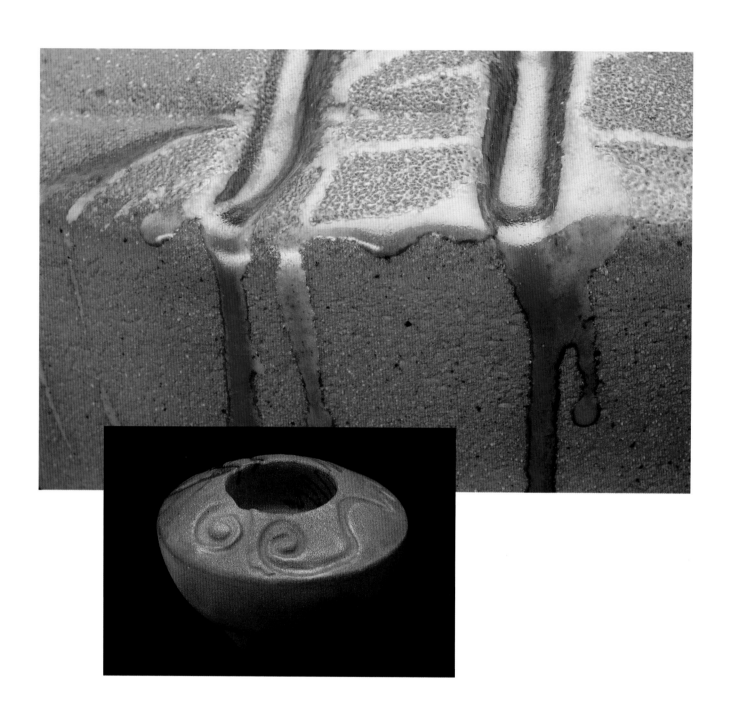

(above) From the *Rattlesnake Canyon* series,
double-walled bowl, stoneware, 1988

(facing page) Covered jar, stoneware, 1987

A Meditation of Fire

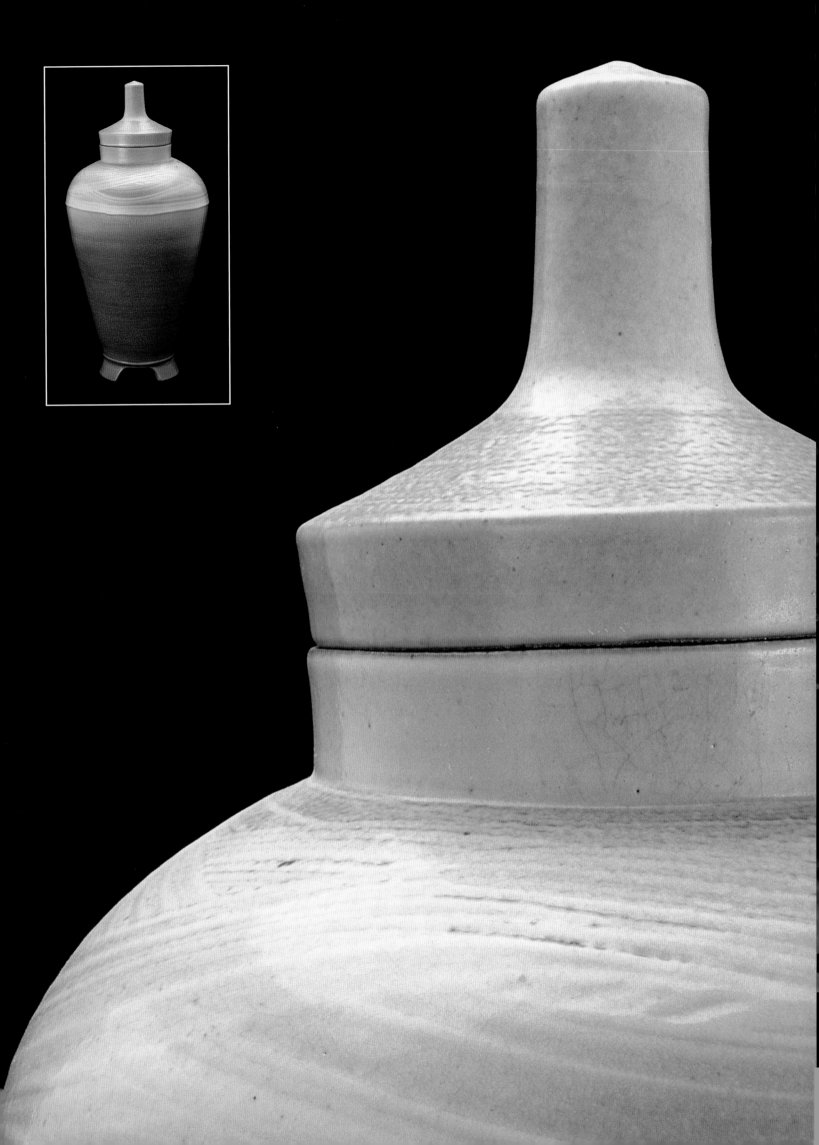

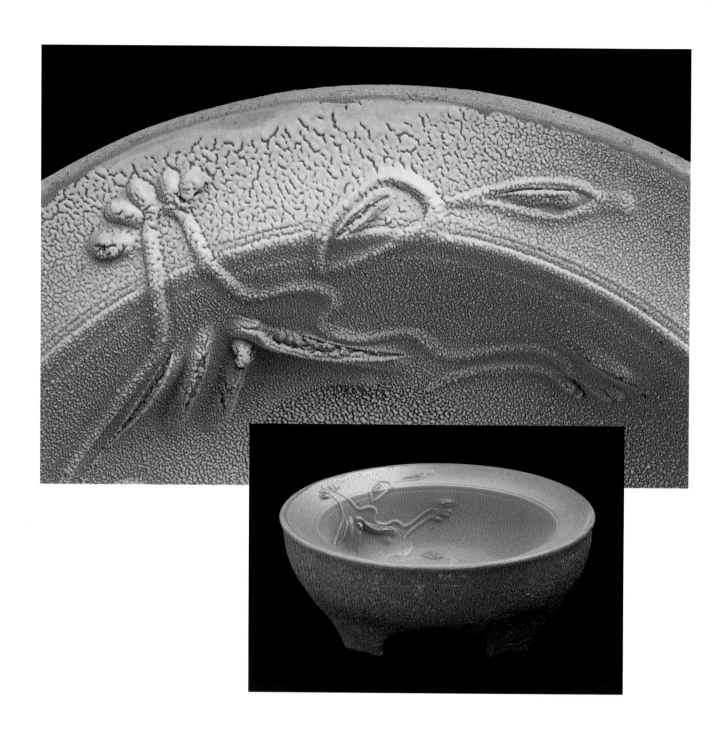

From the *Rattlesnake Canyon* series,
double-walled bowl, stoneware, 1988

CONTEMPLATION 3

The whole of life lies
in the verb seeing.
–Teilhard De Chardin

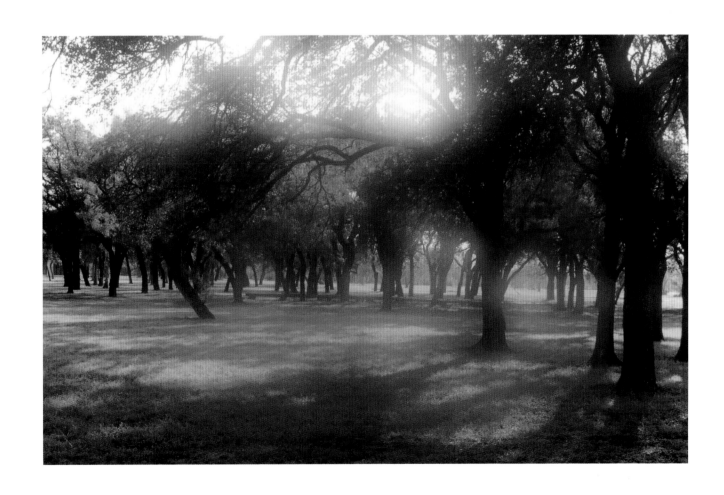

A morning mist lays among stands of live oak, covering the meadow of wildflowers. The mexican hats, Indian blankets, and asters are dense and luminous. The light depicts a surreal vision as five white-tail deer run through tall grasses while another four stand alert this side of the tree line.

Across the clearing into the woods, some turkey vultures fly low. I stay still, watching them glide above me, swooping in and around the tall pecan trees. This orchestration continues until all of us move on.

Down the path I hear the river running, and I suddenly feel as though I recognize the voice of an old friend. The water is high and swift; my friend is strong, and I am heartened. Down the path, I come upon the river a second time and find a trio of turtles basking upon a tree branch in the water. As I continue walking under the lush, verdant canopy, two hawks dash away from their perches. The air is humid and welcoming.

In solitude and quiet, I visit the clean, white, rocky shore of the Llano River. Walking along, I see the old swimming hole, full of water lilies, and I remember hot days when friends and I would swing out from a thick rope and let go, falling into invigorating water. Hearing a plop, I examine the water, and this time I detect six more turtles, all craning their heads above water.

I find a place to sit, and closing my eyes, I hear another distinctive wonder of this place as hundreds of diverse birds sound their calls to the sky and each other.

The symphony of flowing water and consonant birds reminds me of a barn swallows' adobe structure I saw earlier, built safely under a tin roof connecting two huts used by pottery students up the hill. The birds have used jettisoned potters' clay in their labors. The mother and father barn swallow have been flying bravely around the working potters for the past two weeks to protect their four newborns. And just as the barn swallows create shelters for themselves, the potters create shelters for their souls. James Watkins is such a potter.

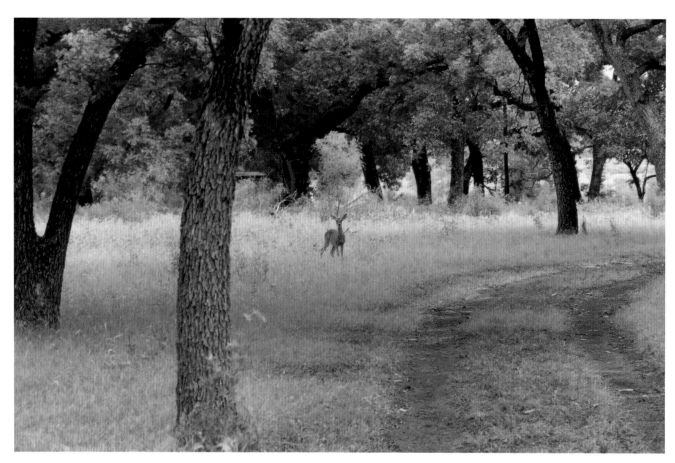

During his walks at Junction, Watkins often sights deer near the Llano River, keeping him connected to the natural world. Deer have appeared in Watkins' work, for example, in the antler-like appendages on the double-walled caldron from the *Guardian* series on p. 119. (© Kippra D. Hopper)

(previous page © Kippra D. Hopper) The light is surreal in a grove of pecan trees near the Llano River at Junction, Texas, an academic campus of Texas Tech University. On his daily two-and-a-half mile walk there, Watkins feels an affinity with nature.

A hot and sticky afternoon, Watkins is wedging twenty-five pounds of clay . . . a hundred times . . . religiously. He moves through this part of the process with the same love one feels when kneading bread. Bending down to the floor to roll out a thick coil, Watkins says he and his family have come to Junction, Texas, for the past fourteen years because of the nature here.

"It's wonderful to be able to see wild turkeys and to hear stories of panther sightings. It's our one time during the year to really commune with nature," he says.

In the screened-in huts, Watkins teaches clay for an intense three weeks to students that range in experience from novices to established ceramic artists, while his wife, Sara, teaches experimental drawing.

To begin their Junction experience, Watkins has instructed his students to make test glaze globes. The small ceramic spheres allow the students to observe ways in which glaze responds, runs, and pulls. Watkins remembers the exercise from his days as a graduate student of the late Karl Martz, who taught for thirty-two years at Indiana University.

"Completely making, glazing and firing the small globes in the first three days of class opens up possibilities in the sense of colors and surfaces. It's also a motivator for the students because they become enthusiastic about creating forms for their newfound surfaces," Watkins explains.

"It raises questions for them. They see that some glazes are opaque and that others are transparent or shiny. Some have visual texture, and some have tactile texture. Making glaze globes quickly takes away the mystery of what chemistry does and introduces the students to firing."

As part of the Junction campus experience in clay, Watkins' students hold vigil around the woodburning kiln, feeding the fire for several days in anticipation of seeing their finished works.

Martz, whose degree was in chemistry rather than art, was well-known for his experimentation with glazes. In an interview conducted before his death on May 27, 1997, Martz said, "I concentrated a lot on the composition of glazes, altering the materials and the proportions of the glaze, and I was interested in discovering what these alterations and changes would do. I contributed about twenty articles to *Ceramics Monthly* that dealt with earthenware glazes. Chemistry gave me a pretty good background for the kind of experimenting that I did."

Watkins carries on Martz's legacy of experimentation in his teaching of clay. "I express to my students my attitude about teaching, which was influenced by Karl Martz and involves the idea that everything does something. So we test everything. I've had my students make a glaze from things they would find in their medicine or kitchen cabinets. Using materials such as Comet, Kaopectate, and talcum powder puts them in an experimental mode."

Experimentation, by its nature, lends itself to students trailing their own ideas, Martz remarked. "I liked to let them follow their own ideas and not be too influenced by what I did or what other potters did."

Throughout his education, Watkins was persuaded by this same conviction. His ceramics professor at the Kansas City Art Institute, Ken Ferguson, also inspired Watkins to develop his own style.

"The best thing about teaching is you have to be loose, you have to be open," Ferguson remarks. "It's a business of trying to help the student develop their talent. I think somebody said one time many years ago that the ideal situation is the teacher and the student entering the studio together, alongside each other. And the teacher doesn't know where the student's going, and the student doesn't know where he's going either. But together they get to a real good place.

"As Willa Cather, the writer, said, 'the end is nothing, the road is all,'" he says.

Ferguson's message in education was to teach functional pottery — "good forms thrown on the wheel, well-glazed, and fired, with a certain amount of integrity, and nothing too glitzy, too clever, smart, or wise."

Learning from Ferguson to make functional pottery, Watkins later began experimenting with conceptual ideas at Indiana University under Martz and another of his graduate professors, John Goodheart, who has watched the evolution of Watkins' work over the past twenty years.

"James' work has always been very singular. He's always used the vessel as his primary vehicle for expression, but aesthetics is one of his artistic priorities," Goodheart remarks. "What I mean by singular is that he makes one-of-a-kind pots. His work is based on an idea, and consequently, while he might do a series of pieces that have the same theme, they're always kind of based on some idea. There's a content to them. Some potters work by instinct and intuition. I think James is a very, very thoughtful potter."

Referring to Watkins' huge double-walled pots, Goodheart comments that many potters make things that are comfortable for their hands, such as functional objects. He contemplates Watkins' pieces in the context of another tradition in the vessel genre that deals with larger forms, such as Greek vessels used as trophies.

"A lot of those pots were not functional but they're used more for ritual, symbolic, or ceremonial uses, and that's the way I see James' work," Goodheart says.

In first learning to throw, Watkins revealed a natural touch—a tactile sensitivity—in his work, whether he was making large or small objects, says Paul Molesky, Watkins' first clay professor at Calhoun Junior College.

"He was just very sensitive that way. He just liked what he felt when he pulled up the clay. I think it's achieved not only with your hands, but also within your soul," Molesky says. "When you can bring out those two things—what's in your heart or spirit and you can pull it out of your hands—I think that's very, very nice. I think James has one hell of an art passion in him."

Molesky credits good teachers for a great deal of Watkins' ceramics success. Watkins' first art teacher, Thomas Brown, who taught at Trinity High School in Athens, Alabama, remembers his student as being one who thought for himself.

"He'd come to me with something that he'd done, and I'd look at it and tell him something that he could have done to make it more finished. It would get to where he wanted it, and he would be satisfied with it, and that would be finished to him, regardless of my opinion," Brown says.

"He never protested anything that I know of except his integrity with his work. He would study what I would suggest about his drawings, and then he would stand up for what he wanted. The whole thing about education is getting somebody to think for themselves."

In acknowledging Watkins' self-found style, Ferguson upon his retirement in 1995 included Watkins' piece *Preening Posture* in an exhibition at the Kemper Museum of Contemporary Art and Design at the Kansas City Art Institute, titled *Keepers of The Flame.*

"I didn't see my influence in very many people in that show," Ferguson says. "The reason that I liked that show so much is that I didn't see that any of the artists were copying me. James' work has always been sort of like James: steady, strong, big, powerful, nothing clever, nothing cute, nothing glitzy. James is a very solid person."

Martz agreed in his memories of Watkins: "I remember that he was a very dignified person, had a distinct presence and was a quiet, self-confident person."

Watkins is a role model for African Americans as well as for other potters, Goodheart remarks, noting that historically, the establishment in the visual art world has not adequately acknowledged the contributions of African American artists.

"James has been in important shows. He's in the White House Collection. His work has appeared several times in *Ceramics Monthly,* which is an international publication for the ceramic arts. So, I think James is really carving out an important reputation for himself at the national level," Goodheart says.

Watkins had his own African American role model in Thomas Brown, who he describes as a renaissance person. Brown believed in teaching his students not only art but the intricacies of jazz, the appreciation of conversation, the intellect of chess and the consequence of all education.

"It always bothered me to see young ones with one- or two-dimensional lives. I wanted to let them know that there was something else they could twist their minds around. If you measure your life by the experiences you have, by the more ways you think, then you'll have a multifaceted life and more dimensions to you," Brown says.

Most of all, Brown shared with Watkins a love for drawing, something he considers to be a foundation and crucial building block for the visual arts. Brown notes that even in the poor school district, his students discovered ways to make art with few materials.

"Some didn't draw with pencils. Some drew with brushes and sticks and whatever else they could find," Brown recalls. "Drawing is the sort of thing that takes place in your head, and you discipline your hand to follow what's in your head. Drawing in its purest form is the controlling of some material thing with your intellect, with your mind, with your concentration.

"I think I impressed James with being able to take a pencil and duplicate what I was looking at. I told him that I suggested he stick with drawing no matter what art form he decided to follow," Brown says.

Watkins stayed with the advice and believes that drawing parallels his claywork. "I first see my forms as a mental drawing, as images in my head. Many of the forms are drawn on paper before I make them. After I create the forms, I deal with the surface as if it were paper or canvas. I create three-dimensional references and allusions to space on these surfaces by doing things such as layering slips and glazes, sanding, sandblasting, incising, or building relief surfaces."

Many of Watkins' forms and surfaces are inspired by his intense observation of nature through drawing. He believes the act of drawing trains one to see more, to view subtleties. His goal is to make his own students understand that drawing is a life-enhancing process.

"You can get ideas and inspiration from seeing shadows, reflections and forms all around you. If you can see—not just identify objects, but really take the time to take a deep breath and look at something, look at all of the aspects and become an acute observer—then you can begin to put some of that down on paper or any material. It's a building-up process, and eventually, you have this wonderful thing that's three-dimensional, and it's standing there staring at you wanting to pop off the surface," he says.

Watkins emphatically believes that anyone can be creative. Carrying on the teachings that were given him, he inspires those both new and seasoned to clay at the workshops in Junction.

Having taken part in these informal and formal presentations with Watkins since 1983, Ken Rosier, an associate professor of art at Del Mar College in Corpus Christi, Texas, says he acquires a zeal from his interactions with Watkins.

"Among the things that I admire about James is his enthusiasm for everybody. Whatever level the student is at, he's always enthusiastic about everybody's work. And that enthusiasm is really contagious. I think that's a real nice aspect of James' personality and aspect of his ability to influence people, myself included," Rosier says. "He also has a tremendous amount of energy. That energy is very influential, and I in turn become energized by his enthusiasm."

Another artist, John Donovan, who teaches ceramics at the University of West Florida in Pensacola, says his observations of Watkins at work has influenced the manner in which he himself works.

"James is somehow able to balance intensity and a great sense of calm at the exact same time, and I don't know how he does it, but it's very inspiring. He is very thoughtful in everything he does," Donovan comments. "It's just a real calm, reserved energy. He works at a pace that he could work at indefinitely. I think he gets energy from working, a regenerating energy. It's kind of like he's giving energy to the pieces and they give energy back to him. That's magical to see."

New to clay, mixed-media artist Sophie Knee of Columbus, Ohio, says Watkins furthers individuality in his classes. "He's the kind of instructor who pays attention to what the student is doing. Instead of just assigning the same projects for everybody, James gets an idea of what each student is interested in and starts feeding us information or showing us techniques that he thinks will help with what we're doing."

The environment at Junction inherently induces creativity, as anyone who has been through the "Junction experience" will declare. Watkins elevates the encounter with art by prompting an experimental perspective in the work.

"The workshops are presented in a way so that an individual can experiment with surfaces really without any reservation or without any boundary. And a lot of people are doing research in particular areas. For example, a lot of folks have worked really hard with pit firing and developed methods that other students have taken with them. And I use a lot of that research in my classes and in the work that I produce and exhibit," Rosier says.

Now Watkins is reaching unlimited students as he is among the first artists to be part of the Smithsonian Institution's Internet Artist Tour. Webmaster Mike Briggs of the National Museum of American Art in Washington, D.C., calls Watkins a visionary for seeing the potential of the Internet for himself as an artist. Watkins' work can be found at http://nmaa-ryder.si.edu/collections/exhibits/whc/watkins.html.

Briggs notes that the Museum of American Art began its Internet initiative to increase a sense of community through the electronic frontier, especially for people west of the Mississippi who may not travel frequently to Washington to enjoy their national museum. "The virtual tour makes art much more friendly and allows people much more of an opportunity to engage with the work. The on-line experience does not replace having an aesthetic experience in a museum, but there are ways to stimulate an intellectual curiosity about art through the Internet. I understand what it's like for people out there to come to our Web site who just happen to love art without much knowledge and then be led along the way by established artists. That's a very wonderful thing," Briggs says.

Whether on the Internet or through the classroom, Watkins approaches teaching with the tenet that "the discipline of making art is not an end in itself but a means of making the individual more intimately aware of phenomena great and small in the external world and the internal world of visions."

The key to the creative process, Watkins considers, is to be receptive, to relax, to absorb everything, and to resist taking anything for granted. "When you absorb, you become full and eventually it will all come out some way through something creative—either writing, drawing, ceramics, sculpture, poetry, music, it doesn't matter.

If you are filled with the wonderful stuff you are absorbing, you have to be creative, you have to respond in some way."

While at Junction, Watkins commences his mornings with a two-and-a-half mile hike around the perimeter of the campus. During those walks, he often remembers the lesson that perhaps transcends all his seasons of wedging, throwing, glazing, and firing pots.

"Every effort is precious; even failures provide you with valuable information. When you're at the last step, putting the pot into the fire, you lose control. You have to let go. You have to learn to accept what you have. The pot can be beyond your own sensibilities, beyond your own capabilities of understanding. It becomes an act of discovery, just as life is an act of discovery."

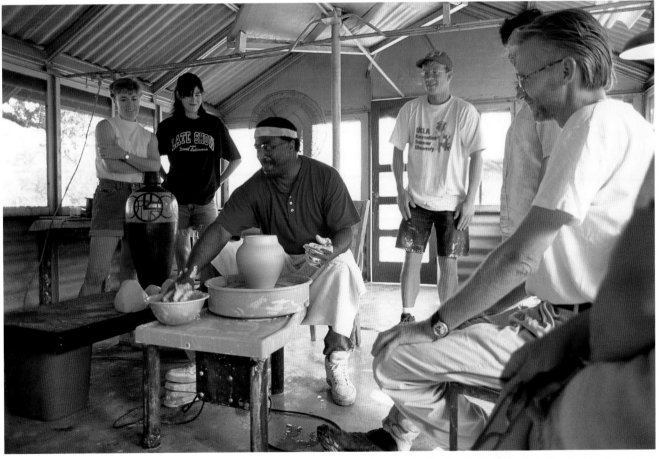

Watkins elevates the encounter with art by prompting an experimental perspective in his students' work at Junction. Here he demonstrates how to make a large teapot.

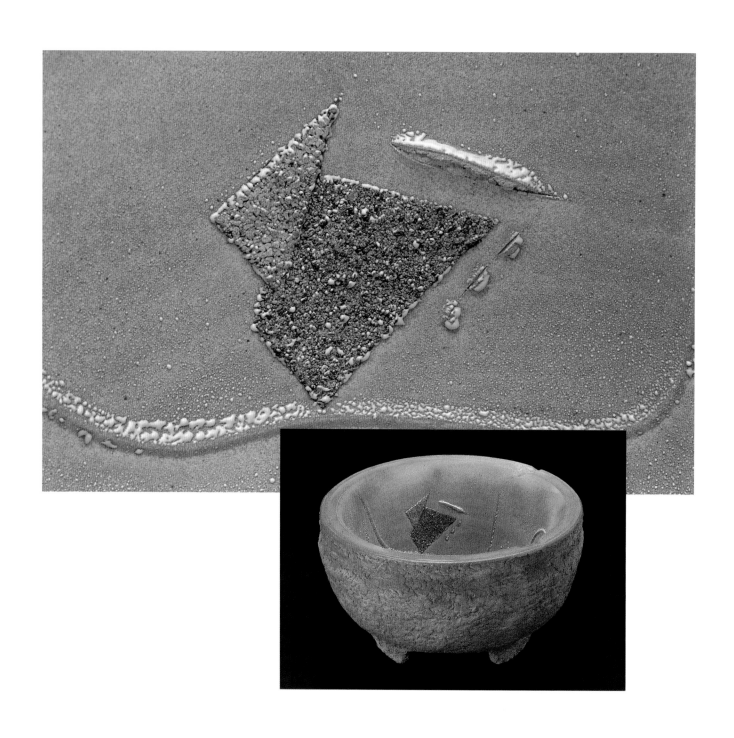

From the *Rattlesnake Canyon* series,
double-walled caldron, stoneware, 1988

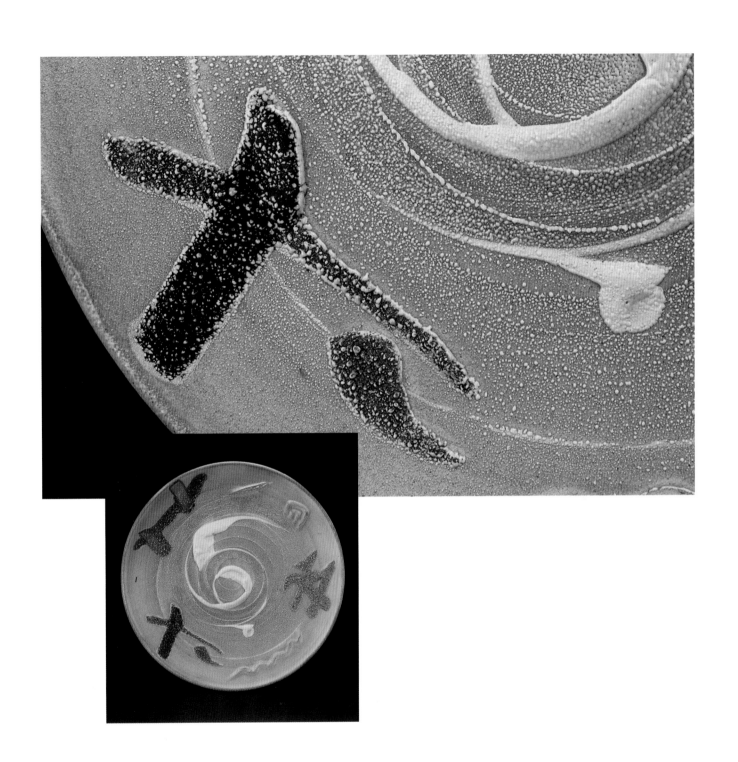

From the *Painted Desert* series,
platter form, stoneware, 1989

CONTEMPLATION

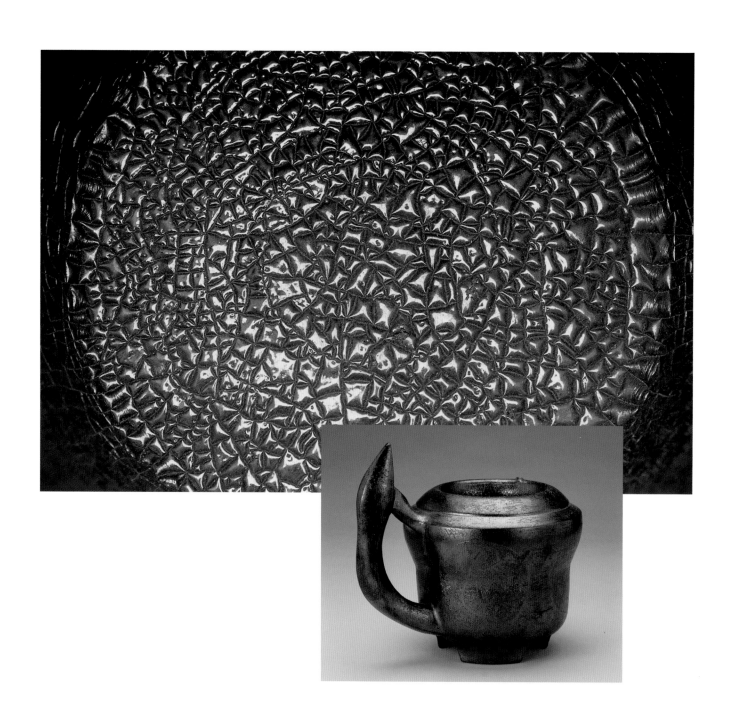

A Meditation of Fire

Double-walled bowl,
saggar fired, 1993

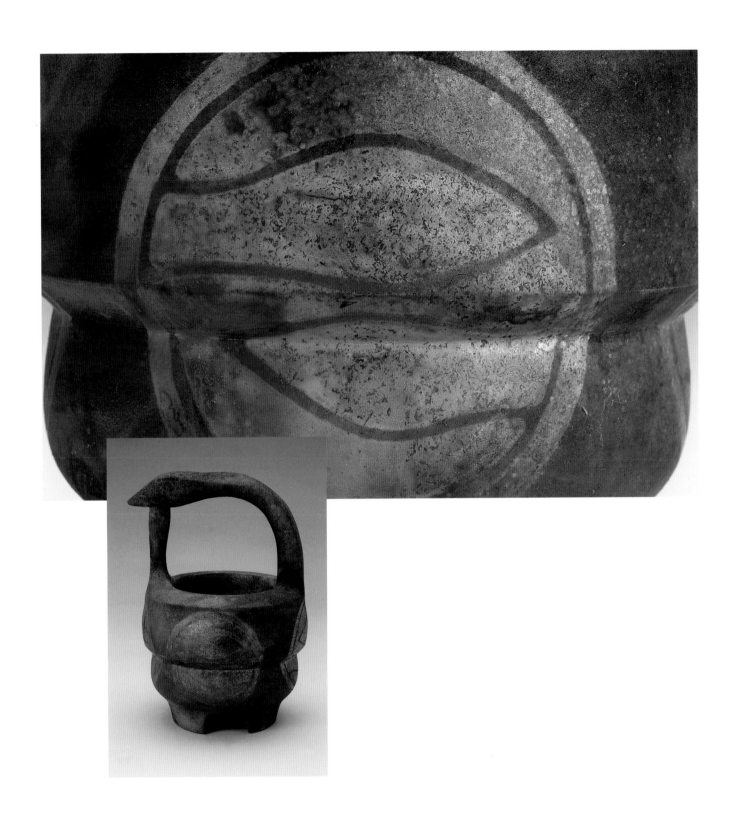

Bird Basket,
raku fired, 1995

CONTEMPLATION

VISUALIZATION 4

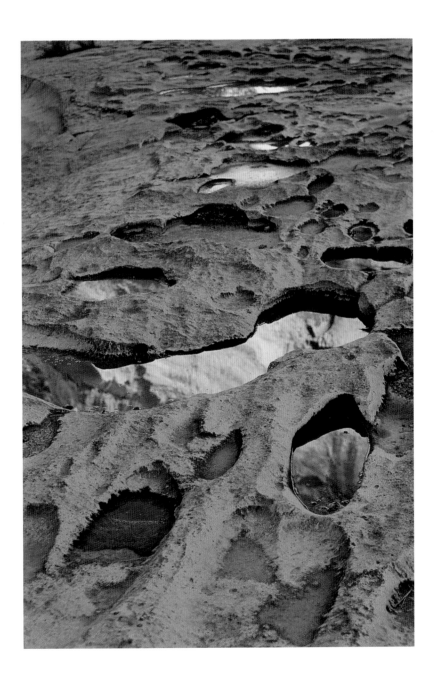

The enquiry into a dream
is another dream.
—**George Savile,
Marquis of Halifax**

Hiking through Skiles Ranch toward Eagle's Nest in a canyon of massive proportions, we climb over limestone boulders and around *tinajas*. These large, natural depressions in the rock collect rain water, providing a life force to wildlife and early humans alike. Along the Lower Pecos River and the Rio Grande, near the Texas-Mexico border, primitive rock art depicts scenes of human figures, animals, and various shapes and symbols of uncertain meaning in hues of red, brown, black, and ocher.

We are here to see the mystic images left behind by ancient peoples on the walls of caves: shamanic figures, deer, mountain lions, raccoon, catfish, cacti, bows and arrows Not knowing exactly what the pictographs mean, we sense that the art reveals something eternally important. The shelters visited—named Fate Bell, White Shaman, Rattlesnake Cave, Panther Cave, Eagle Cave, and Bonfire—undoubtedly are prodigious. They are nothing less than sacred sites; in a place like this, we are reminded of the insignificant size of human beings.

Early interpretations of the symbols—which date back more than 4,000 years—involved the general idea that the main figures in the rock art represented shamans who probably went into trances in order to voyage into the spirit world. More recent analyses suggest that shamans most likely ingested psychoactive plants—such as jimson weed and peyote found in the region—before creating the images inspired by their hallucinations on the shelter walls.

Potter James Watkins is aesthetically moved by these impressions, and he revisits the sites to behold again the enchanted remains of cultures long gone. The images overlap one another, and because of this, Watkins believes that to these ancient peoples, the act of creativity was more critical than the marks that resulted. The ritual of art brings meaning to the ceremonies of life. We must hike long and arduous distances—sometimes

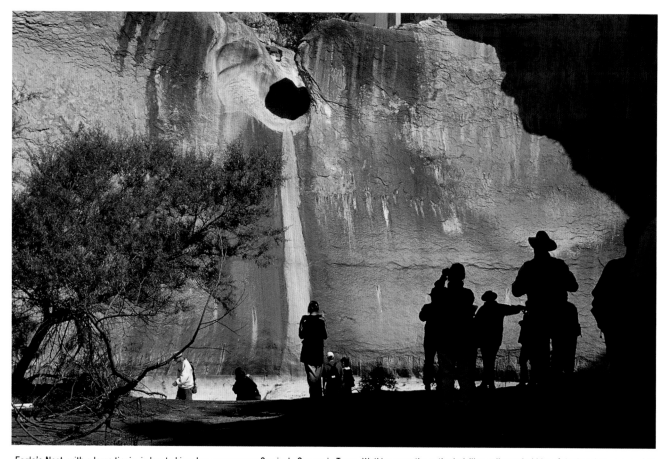

Eagle's Nest, with a large tinaja, is located in a box canyon near Seminole Canyon in Texas. Watkins says the cathedral-like walls remind him of the interior spaces of his double-walled caldrons. He often draws images on the interior walls to pull the viewer inside, as seen in the double-walled bowl from the *Guardian* series on p. 126.

(previous page) In Rattlesnake and Seminole canyons, one can see ancient tinajas, the natural depressions in the rock that collect rain water. These exaggerated textures can be seen in the textures of Watkins' works, as in the double-walled bowl on p. 46.

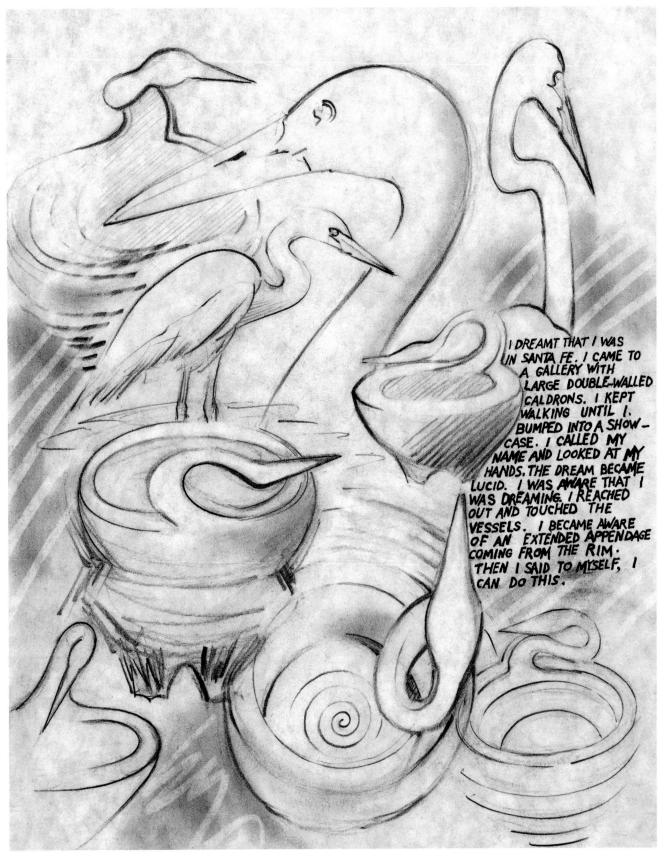

I DREAMT THAT I WAS
IN SANTA FE. I CAME TO
A GALLERY WITH
LARGE DOUBLE-WALLED
CALDRONS. I KEPT
WALKING UNTIL I.
BUMPED INTO A SHOW-
CASE. I CALLED MY
NAME AND LOOKED AT MY
HANDS. THE DREAM BECAME
LUCID. I WAS AWARE THAT I
WAS DREAMING. I REACHED
OUT AND TOUCHED THE
VESSELS. I BECAME AWARE
OF AN EXTENDED APPENDAGE
COMING FROM THE RIM.
THEN I SAID TO MYSELF, I
CAN DO THIS.

A page from Watkins' dream journal shows the beginnings of his double-walled forms with the bird appendages.

crawling along goat paths—to find these sacred cathedrals. Each of us dreams a different vision during the nights that follow about the meanings of the "Rabbit Man," "Giant Centipede," and the "Great White Shaman." The visions are imbedded in our minds, even as their impressions wear away from the rocks . . . and we struggle for the ability to keep and see them forever.

In the visions of those from the past and in his own experiences of nature, Watkins discovers inspirations for his artistic quests. What he dreams at night becomes the forms he throws on the potter's wheel then offers to the flames of the kiln.

American Indians left a visual legacy as in this pictograph "White Shaman" near Seminole and Rattlesnake canyons. Pictographs have influenced Watkins work in the layering of images on the surfaces. "White Shaman" particularly influenced the platter from the *Rattlesnake Canyon* series in its images of people in flight, seen on p. 99.

A M e d i t a t i o n o f F i r e

Several years ago, on his first trip south to Rattlesnake Canyon with eleven other artists to explore the American Indian pictographs, Watkins got lost driving at dusk in the desert on a dirt road that crossed ravines and washes. A huge snake, the largest he had ever seen outside of a zoo, crossed the road, and he accidentally ran over the reptile.

"It sounded and felt like a speed bump. I stopped the van to get out to see the road kill, but I couldn't find the snake anywhere. I got very paranoid and began to think that the snake had wrapped itself around my motor and was going to crawl through the vents and eat me alive while I was lost in the Pecos wilderness. As soon as I got back home, I made a pot that I call *Snake Crossing*."

Personal experiences and the documentation of his dreams are major sources of inspiration for the potter. Since graduate school, Watkins has practiced lucid dreaming, or the act of becoming conscious while dreaming and remembering one's dreams. Through these revelations, creative innovations emerge. "I am actively participating in the rite of remembering. I am intent on using this rite as a creative mechanism," Watkins says.

His double-walled caldrons are a response to a dream in which he resolved an engineering problem he was encountering in making very large pots. "I was always trying to make very large bowls. I wanted to make them twenty-four inches wide, but they would always warp in the kiln. Then one night I dreamed that I was in Santa Fe, and I was walking into the plaza and I looked through the window of a gallery. I saw my pots, but they were double-walled. I walked past the window, and it was as if I didn't get the message," Watkins remembers. "Then I bumped into a glass wall, and I jarred myself and became conscious that I was dreaming. So I looked again, and the glass went away, and I touched the pot. In examining it, I figured out how it was made, and I told myself that I could do that. So I woke up the next morning and I made the first, big, double-walled pot."

American Indians used bedrock mortars, like these at Rattlesnake Canyon, for grinding paints for pictographs. The forms influenced several of Watkins' double-walled bowls, as the pot seen on p. 98 from the *Rattlesnake Canyon* series.

VISUALIZATION

The twenty-four-inch pot survived firing because architecturally the two walls are strong enough to prevent the object from warping in the kiln, he explains. The sculptural dimensions of animal and architectonic forms in his work also came about through a dream.

"In a dream I saw forms with heads and appendages coming out of the pots, and the next day I made my first pot with a bird form. There's an endless variety of things I can do with that rim."

The iconography and imagery in Watkins' large-scale, double-walled caldrons and platters is metaphorical in nature, comments Joshua Green, director of ceramic art at the Manchester Craftsmen's Guild in Pittsburgh, Pennsylvania, where Watkins conducted a workshop and exhibited seventeen of his pieces in 1994. "He seems to be more deliberately going after an investigation of mythology—from his African American heritage, the Texas peoples and the American Indian—and a kind of metamorphosis myth," Green remarks.

"I think one of the beauties of his working in the caldron format is that the caldron, in and of itself, has this kind of metaphorical role in that when you cook things, they become transformed. The intermingling of ideas are flavors as it would be in a literal caldron, and that becomes part of a metaphor for the process that James is using," Green says. "The pieces emerge from personal stories, as well as stories that are mythological or legendary from his family history and from past cultures that fascinate him. He combines all of those stories within the same object as a metamorphosis."

In a review written for the exhibition, Green suggests that Watkins' caldrons evoke a life of extended families and tribal cultures wherein the hearth exists as the center of the home. He continues: "The caldrons' surfaces appear to be blackened with heat and use like the surfaces of ritual objects painted with sacramental materials or dramatically altered by trials of fire.

"The central ideas behind ritualistic objects is that somehow through handling, behavior, and belief, these inert vessels acquire the ability to transform that which they hold from something mundane into something spiritual. This is no mean feat, and Watkins' works serve as a kind of theater in which to hold this drama. The birds and snakes rendered sculpturally as handles and undulating lips appear as shadows or fire scars on the vessels' interiors. They beg us to focus our attentions there where mystery becomes manifest. The choice of these animal forms also suggests a duality of good and evil or perhaps heaven and earth, making these vessels a place where these seemingly opposing forces coexist in an endless cycle of birth and death, consumption and reemergence"[1]

Green further discusses clay itself as serving as the embodiment of cosmological, geological, and cultural memory. He states that during the past twenty years or so, researchers increasingly have focused on ceramic materials in their search into the origins of life, language, and civilization. Artists are the inheritors of recollection, and potters are the first material scientists, he writes.

"Magnificent pottery cultures have appeared and just as mysteriously vanished throughout diverse points on the globe. But fired clay is durable, and the objects made of it, like memories, have the ability to survive the political upheaval, climatic change, and onslaughts of disease which might account for the crumbling of cultures. It is perhaps as a result of this stubborn resilience that pottery and other craft forms persist today as transmitters of vanished customs and beliefs," Green states.

The significance of dreams is a notion that has been passed down to Watkins from his mother and grandmother. One of the key concepts in contemporary African American craft art is dreams, notes Nkiru Nzegwu, associate professor of art history at Binghamton University in Binghamton, New York. After talking with more than forty African American crafts people, including Watkins, Nzegwu found that a key concept that repeatedly figured in the artists' discussions of their works was dreams.[2]

In an interview, Nzegwu states, "Some artists have used dreams in a very critical way, given their various spiritual searches. And the spiritual searches are not necessarily tied to a specific religious denomination but are one way of gaining a fuller understanding of who they are and what their purpose and objectives in life are."

She comments that a number of the artists talked about learning the importance of dreams through family members, particularly mothers. "They talked about how their mothers perceived life and how dreams were used in terms of either reconnecting to ancestors or re-establishing identity along a specific path."

Within Watkins' early family context, dreams and personal mythology played a consequential role as a way to access information, to harness the good life, to ward off evil, and to bring good fortune to the family, Nzegwu says, referring to Watkins' parents' belief in particular benefits of certain colors.

She writes that many of the artists reveal themselves to be 'walkers in the spirit,' an Igbo expression from the West Coast of Africa. She explains that the phrase means to move past the everyday time frame and recognize other realities that cannot be seen, as in dreams and the subconscious.

"To walk in the spirit means having a wider scope and a much more enriched understanding of realities and our place within a wider spectrum. People are redefining the concept of space and time," she says. "In any part of the West African zone I am referring to, people might talk about ancestors, the spirit or their deceased great-grandmother having visited them either in a dream or in reality, and it is a plausible thing in that culture."

She notes that among African Americans, cultural amalgamation has occurred, and notions about dreams are trajectories of cultural legacies and cultural heritage. Having found resolutions in the dream state to technical and aesthetic puzzles of building pots, Watkins has made use of an ability commonly explored in African American craft.

"Oftentimes the dream state functions as a way of seeing even the intangible nonphysical entities. It means expanding one's frame of consciousness, or one's psychic self, to be able to apprehend other entities that are part of realities we inhabit. It involves developing the inner strength and the inner power to directly and consciously use one's dream state," Nzegwu says. According to her, in African American culture, individuals rely to a great degree on concepts such as the dream state, because such ideas are a part of a cultural legacy and were crucial in individuals surviving enslavement.

"The type of survival strategies blacks have had to adopt to go through a very hostile, dehumanizing, brutalizing experience has involved intuition. These interactions, of which dreams are one, are part of the ways that these psychic abilities—which every human being has—have been kept alive and have been fostered. It's very much a living and flourishing part of the American environment," she says.

Watkins' art has germinated from an individual who has been rooted in the culture in a specific way, she comments. "Art is something of who you are, what your legacies are, your culture, your narratives that you've acquired over the years, how that has shaped your vision, how you have selected things that are salient to you. It's that whole context that really speaks and gives a sense of the particular work you've done."

Green writes about the influences of art and personal memory, what he calls an artifact of experience. "James C. Watkins makes pots which speak of memories both personal and collective. We receive personal memory as a result of experience unfolding dispassionately in time and space. But unlike experience which occurs and just as quickly vanishes moment by moment, memory is a subjective endeavor. We pick, choose, filter and distill to create a trove of mental images and physical sensations. Memory exists in a mind which envelopes the entire body, not just the brain. It encompasses scent, taste and touch as well as sight and sound. Whereas experience may be gathered randomly like any number of stones in a field, memory is somehow selectively fashioned."[3]

Watkins' metaphorical vessels hold a sense of family and history, notes Richard Burkett. "I think James' interest seems to be in keeping the vessels still containers, even if they become metaphorical vessels. Historically, they have references to vessels like ancient Chinese forms and a lot of the footed vessels of earlier eras. But, I think they are still abstractly modern in their cleanness of form.

"I would say his work probably includes more references to folk art and folk art heritage than a lot of work that deals with more social issues or pushes things into the abstract sculptural mode of artwork. I think what makes his work strong is that there's a narrative content—a strong story being told—in each piece," Burkett says.

The stories Watkins tells through his work and in his workshops across the country bring an added dimension to the art. Watkins is a natural storyteller, something that adds to being a good teacher, says Gail Kendall, professor of ceramics at the University of Nebraska at Lincoln, where Watkins spent a one-week residency in 1989.

"He has good stories, and he has the ability to tell good stories. Everybody has things happen to them or they have insights that are interesting or mean something to them, but then to be able to find the language and the style to deliver a story and be really effective is kind of a gift. Through the history of my own education, I remembered stories the most," she says.

Kendall mentions that in the history of the human race, the oral tradition of folk tales and storytelling has been a common way of passing on knowledge. "Until the printing press, it was the way people learned. I appreciate art that has historical attachments the way James' work does," she says.

Watkins grew up hearing stories; many of those tales cultivated in him a potent belief that a spirit world exists. Specifically, he relates a couple of ghost stories that his mother told him.

Watkins' maternal grandparents built a new house as part of a Farmer's Home Administration loan program in which farmers could obtain a loan for construction. The house was believed to have been built on Cherokee burial land.

"One evening they were all sitting around listening to the radio, and the dog, Pup, started barking. The sun was going down, and Pup was in the middle of the yard jumping up and down. My mother said the hair on his back stood up, and he was jumping at something in the air. My mother and grandparents believed that animals can see ghosts and spirits. The spirit got closer and closer to the house, and Pup was going crazy trying to keep it out of the house. Finally the dog ran up to the house and sat shivering right at the door. My grandparents and mother closed the door, and they all started praying until the ghost went away," Watkins recounts.

Watkins' mother also told him a story about a day when her father and all of her brothers were away at work, while the women were outside the house washing clothes in a big, black pot. "The women heard furniture in the house being moved. They started calling all the names of the men, thinking someone had come home early, but nobody answered. So they situated themselves on both sides of the house so they could see if anybody came out. The guns were inside the house. The women just waited for hours, hearing these sounds. Finally when the men came home, they went into the house, and all of the furniture had been rearranged," Watkins recalls. "I grew up hearing those stories and having to stay in that house, and there was not a night that went by that I did not ponder those spirits."

The dreams and stories of Watkins' life are threads in a tapestry. He comes to his art with great sensitivity of touch. "His clarity of vision identifies him as a medium of vital spiritual force," comments Nzegwu.[4] Along with these cultural threads, Watkins believes art entails in him a passion to create.

"Art transcends mediums. It has something to do with passion; it's not something that can be rationalized easily. It's about a passion to want to create something in the best way possible. It doesn't necessarily entail a social meaning or political significance, but passion has to be involved," Watkins says. "By passion, I mean love. Observers of the work will, in turn, feel that, even if the artist isn't necessarily trying to evoke a response. It's the nature of humans, that if there's passion, then it's naturally going to transcend into other passionate human beings. If you're doing something you love, time doesn't exist anymore. If you don't have that passion, the work would be torture."

Green remarks that Watkins is able to convey that passion to others and is a role model for all students. "I think he places a high value on being an educator, and he is able to communicate his ideas and thoughts to students as well as to working potters. He's really a terrific spokesperson and role model, particularly for the young African American student. He's made up of his culture, and at the same time, he's incredibly articulate and sure of himself and his abilities to work in a variety of worlds, whether academic or artistic. He's just very comfortable with who he is. He's managed to integrate all aspects of himself into his journey."

Despite the inadequate acknowledgment of black ceramicists by the art establishment, African Americans always have created pottery. The African American design legacy in the United States can be traced to colonial times. Watkins is gaining visibility as a major American ceramic artist, and as such, he has been accepted into the African American Design Archive at Cooper-Hewitt National Design Museum of the Smithsonian Institution in New York City.

Watkins says that the insatiable need to be creative, to leave a record of visual language that records our perceptions of the world around us, is a common thread that binds all cultures. "The magic of art is that it has the potential of being a cultural link that bridges varied temperaments and sensibilities."

Potter James C. Watkins believes in dreams; he lives with passion and receptivity. His history and his observations eventually reemerge in his work—like a Phoenix out of fire.

Notes

1. Joshua Green, "Container and Content," unpublished ms., 1994.
2. Nkiru Nzegwu, "Living in a Glass House, Passing Through Glass," *The International Review of African American Art* (1994):45.
3. Green, "Container and Content."
4. Nkiru Nzegwu, "The Legacy of African American Craft Art," in *Uncommon Beauty in Common Objects,* edited by Barbara Glass. (Wilberforce, Ohio: National Afro-American Museum and Cultural Center, 1993), 102.

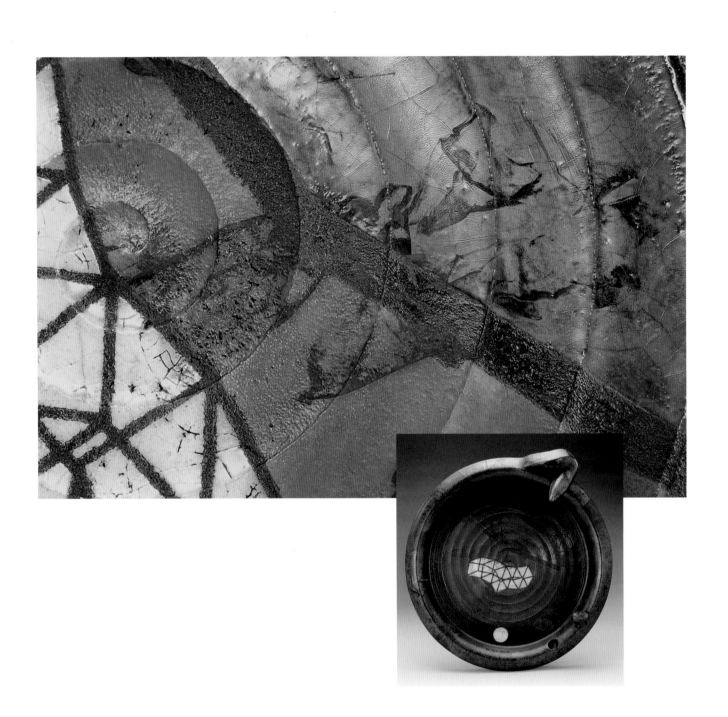

(above) *Intimidation Posture*, double-walled platter form,
raku fired, 1995

(facing page) *Ritual Display*,
raku fired, 1995

A Meditation of Fire

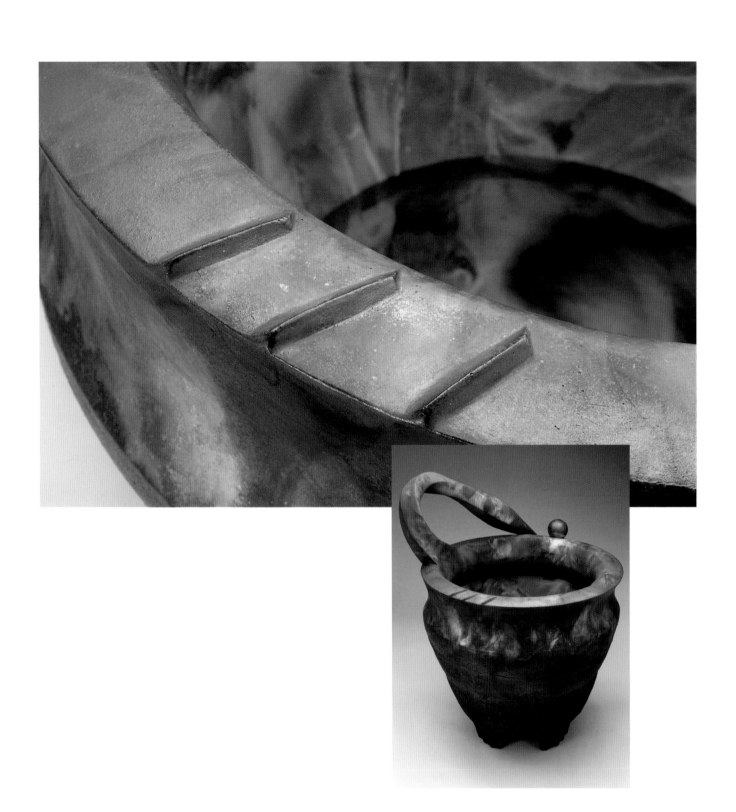

Preening Posture with Ball,
double-walled caldron, raku fired, 1995

MANIFESTATION 5

The artist is a receptacle for emotions
that come from all over the place:
from the sky, from the earth,
from a passing shape,
from a spider's web.
—**Pablo Picasso**

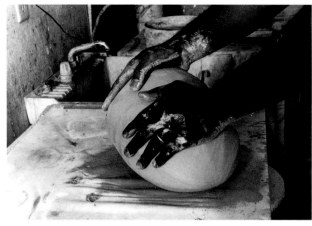

To make a strong, double-walled raku caldron, a strong
clay body that is capable of withstanding the stress of rapid firing
and cooling without cracking, is first created. Through trial-and-error,
Watkins has developed the following clay formula: 10 parts fire clay, 5 parts
ball clay, 2 parts grog, 1 part Custer feldspar, ¼ part spodumene. (Grog is
a hard-fired clay that has been crushed or ground to various particle sizes.
It is used in raku clay bodies to reduce shrinkage, which helps to prevent
cracks.) The clay is wedged one hundred times to eliminate any air bubbles.

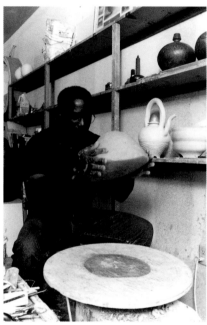

To begin centering the
twenty-five pounds of clay, Watkins pounds
the clay on the wooden bat of the wheelhead.

The ball of clay is opened to begin throwing
the initial large, single-walled bowl shape.

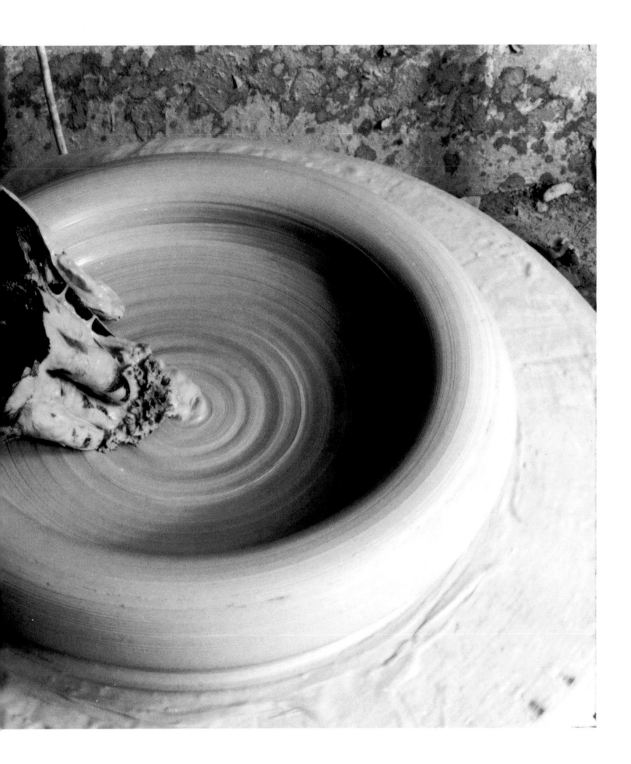

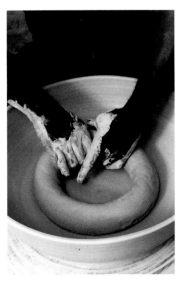

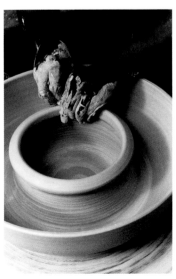

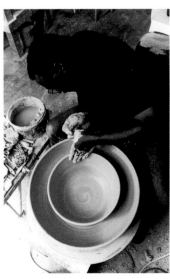

Inside the bowl form,
the second, interior wall is
started with a large coil of clay.

The interior coil of clay
is centered and pulled up
to form the sides of the pot.

After centering and pulling up
the interior coil of clay, Watkins
leaves the two walls to stiffen.

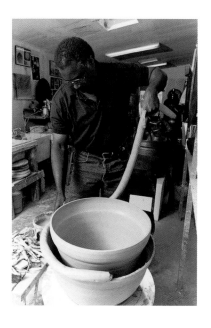

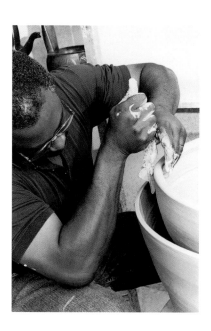

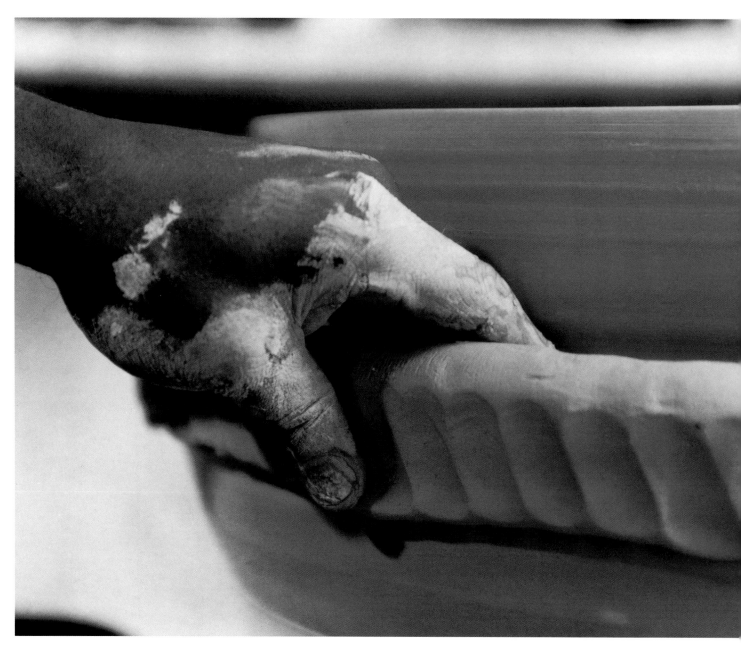

A Meditation of Fire

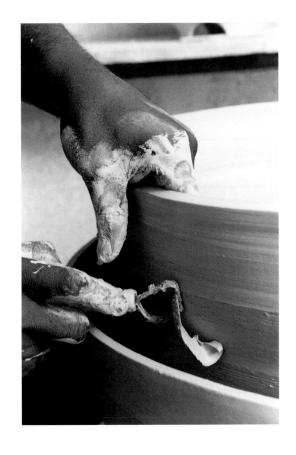

Many tools are used to scrape,
cut, paddle, measure, and trim the forms.

When the walls are stiff, a coil of clay is
rolled out and placed on top of each wall.

Watkins uses a tool to compress the
inside of the wall to ensure it is consistent in
width. He pays as much attention to the inside as to
the outside of each wall so that the seams do not show.

Using his thumb, he attaches
the coil to the outside rim of the form.

The inside wall is trimmed for consistency of width.

The coils are centered on each rim and
pulled up to make the pot taller. Watkins repeats the
process until he achieves the desired shape and height.
The inner wall is slightly higher than the outer wall.

The inside wall is turned down to
meet the outside wall, closing the rim.

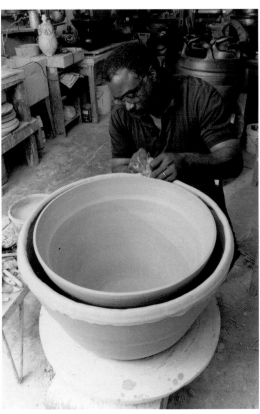

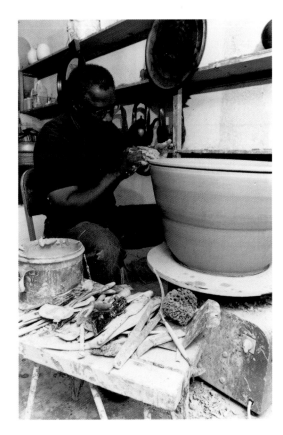

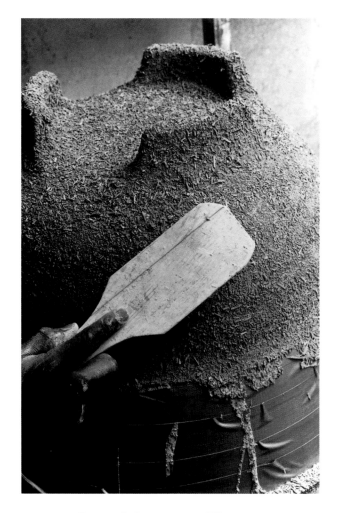

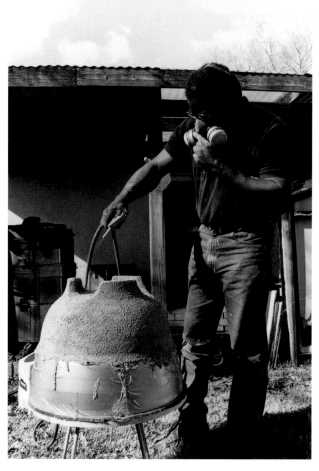

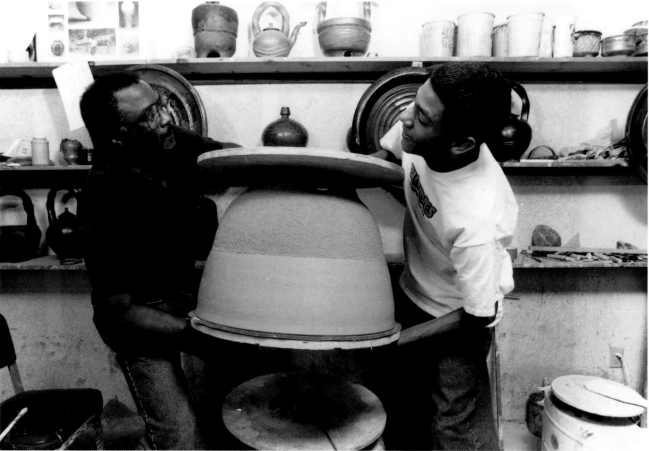

A Meditation of Fire

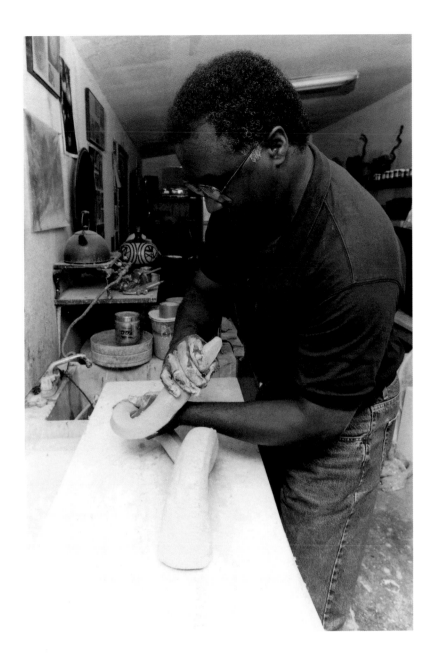

The trimmings are paddled
so that they stick to the slip.

By sandblasting the textured
outer wall while the clay is still wet,
Watkins creates a sandstone effect.

When the feet are stiff
enough to support the weight of
the pot, Watkins and his son, Zachary,
turn the pot right side up so appendages
can be added to the rim of the pot.

Bird-shaped appendages
are made from solid clay.

Cutting the shapes in half,
he hollows out the forms when the clay
has stiffened to leather-hard consistency.

After the two pieces are
scored with a fork, slip is added
and the pieces are put back together.

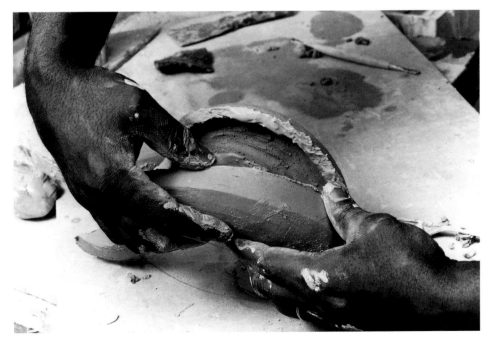

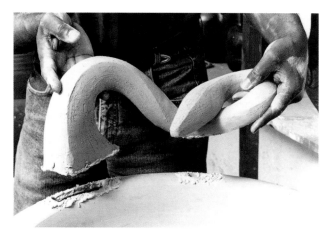

The appendages are attached with slip to the rim of the pot.
A hole is cut in the pot to allow air to flow through so the attached
form dries at the same rate as the larger form to prevent cracking.

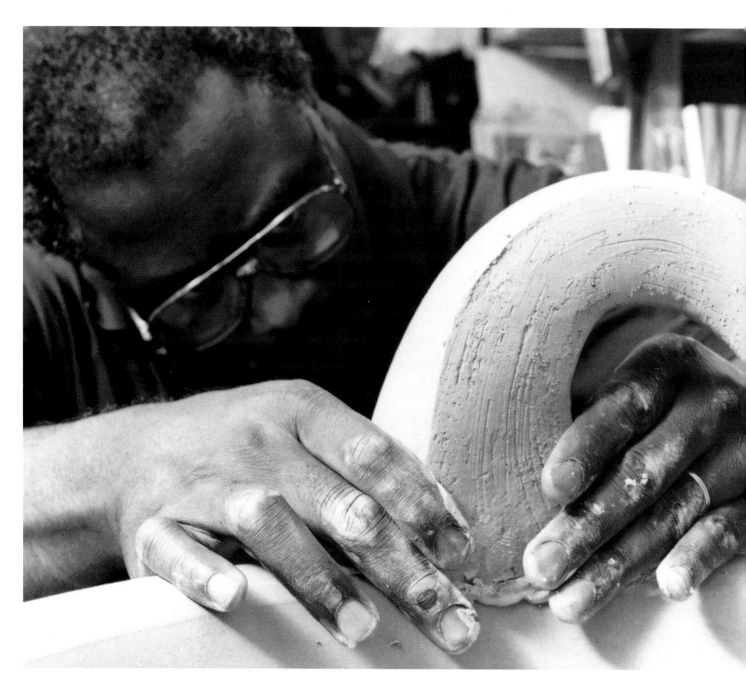

A Meditation of Fire

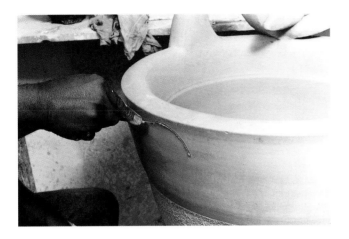

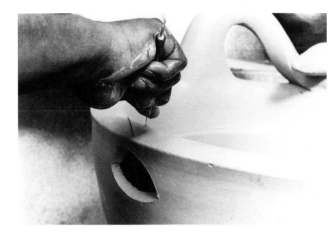

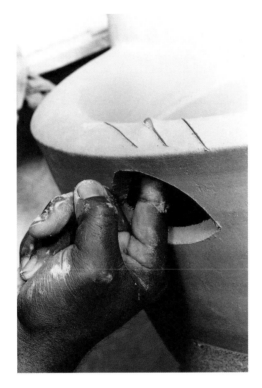

The outside surface of the double-walled form is cut
in order to add elements of depth to the surface of the pot.

Using his finger to push out from the inside, Watkins
creates a form that is breaking through, as a seed pod or flower.

Using a popsicle stick
that is carved into a half-circle on the tip, he
trims the wet clay to obtain a rippled surface, as a shell.
The form is then attached to the rim with the appendages.

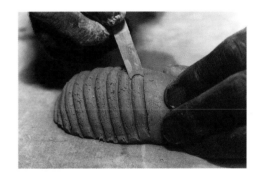

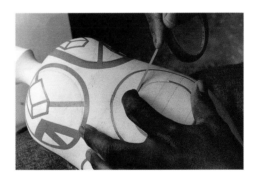

After drawing images onto the surfaces of
the bisque-fired pot, Watkins outlines the drawn areas
with automotive striping tape on both the exterior and
the interior walls of the forms. Bisque firing is a preliminary
firing that hardens the clay body prior to the glaze firing.

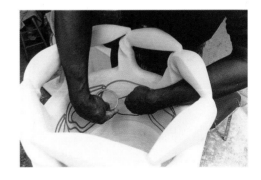

MANIFESTATION

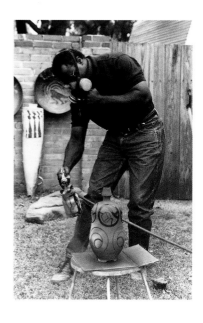

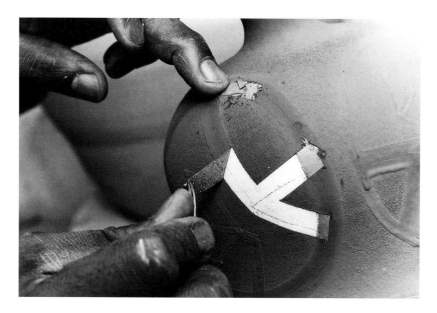

The bisque-fired piece is glazed by spraying over the masked surfaces with a spray gun. The glaze formula is as follows: 45 percent copper carbonate, 45 percent copper oxide (black), 15 percent Frit 3110, 5 percent cobalt carbonate, and 10 percent red iron oxide.

The tape is peeled from the glazed surface to reveal the drawings. The pot is then fired to Cone 06.

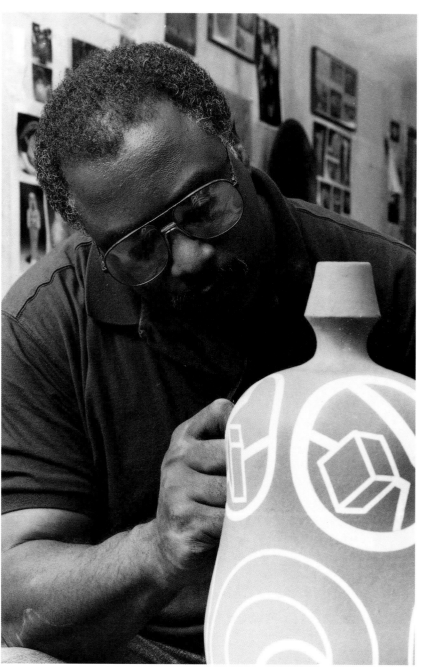

A Meditation of Fire

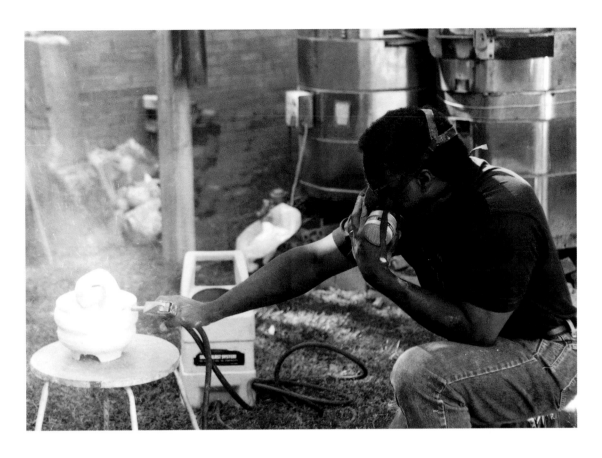

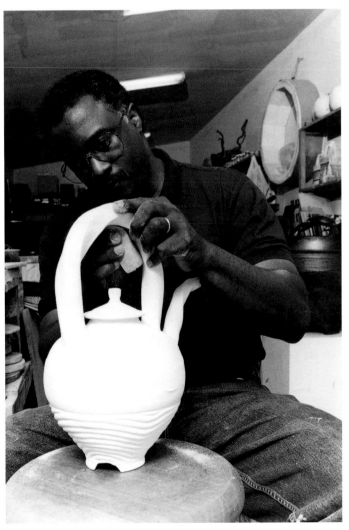

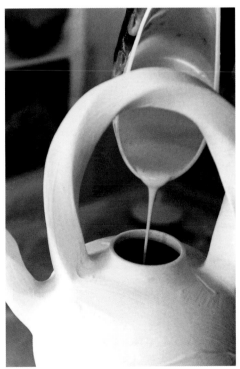

On some occasions, Watkins sandblasts a
bone-dry pot to give it a stone-like texture.

The surface of a bisque pot
is sanded to get a smooth surface.

Glaze is poured inside
a teapot to cover the interior surface.

Terra sigillata is painted onto the surface of a double-walled caldron that has been fired to Cone 06.

Buffing the surface with a chamois gives the pot a glossy sheen.

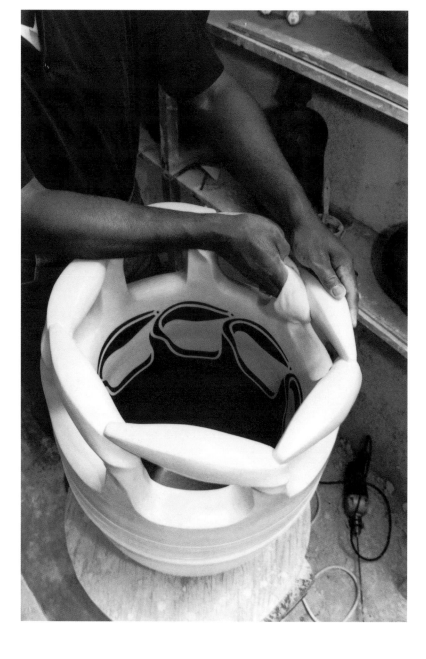

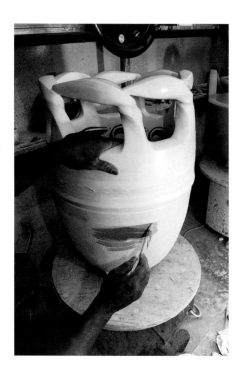

Double-walled caldrons are refired to Cone 012 or 1623 degrees Fahrenheit. When the kiln has reached the correct temperature, the pot is pulled out, placed in a container in the ground, and covered with paper or sawdust, which are combustible reduction materials. Reduction materials smoke the piece, giving it the black, carbon surface.

The pot is left to cool in the covered container. The sawdust is removed from the reduced pot after it has been covered overnight.

Finally the finished double-walled caldron is pulled out of the ground.

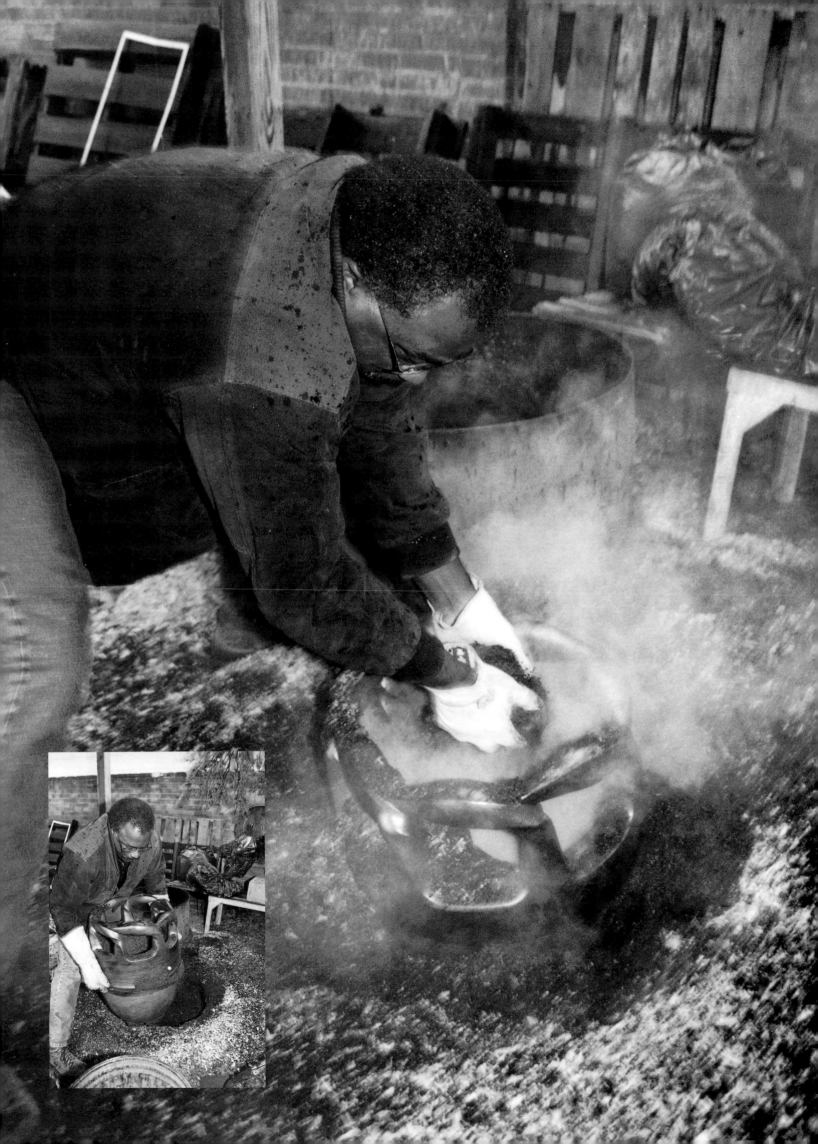

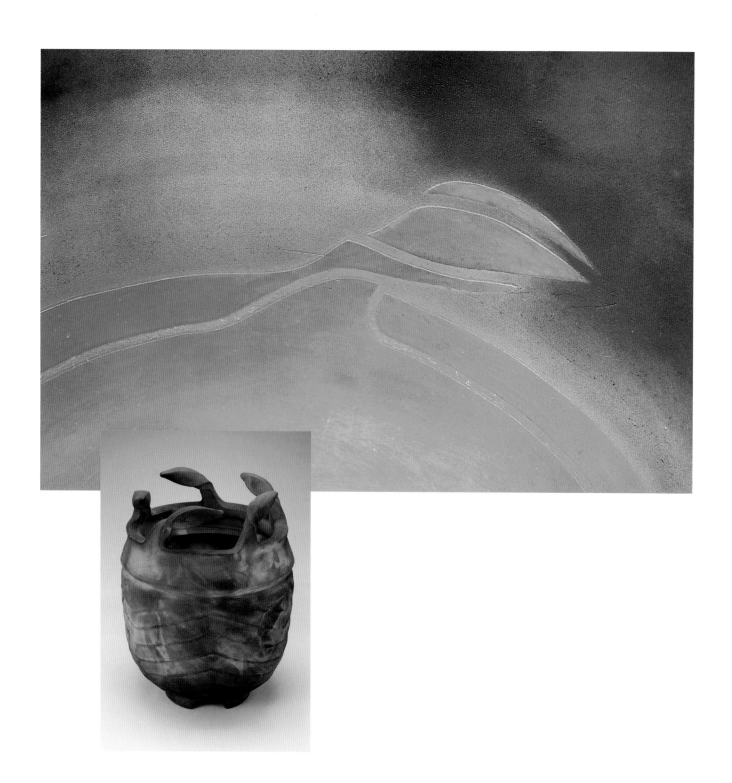

A Meditation of Fire

From the *Guardian* series,
double-walled caldron,
raku fired, 1996

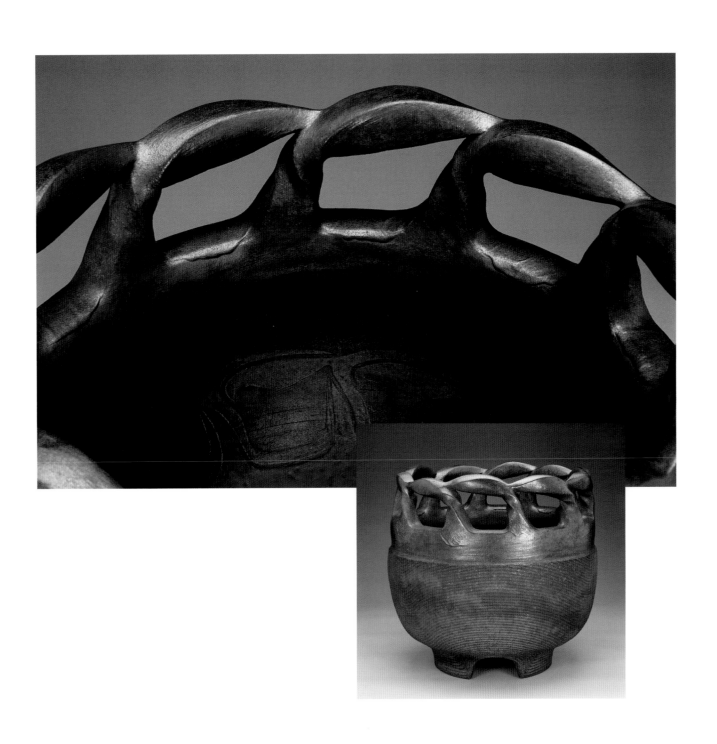

Communion, double-walled caldron,
raku fired, 1998

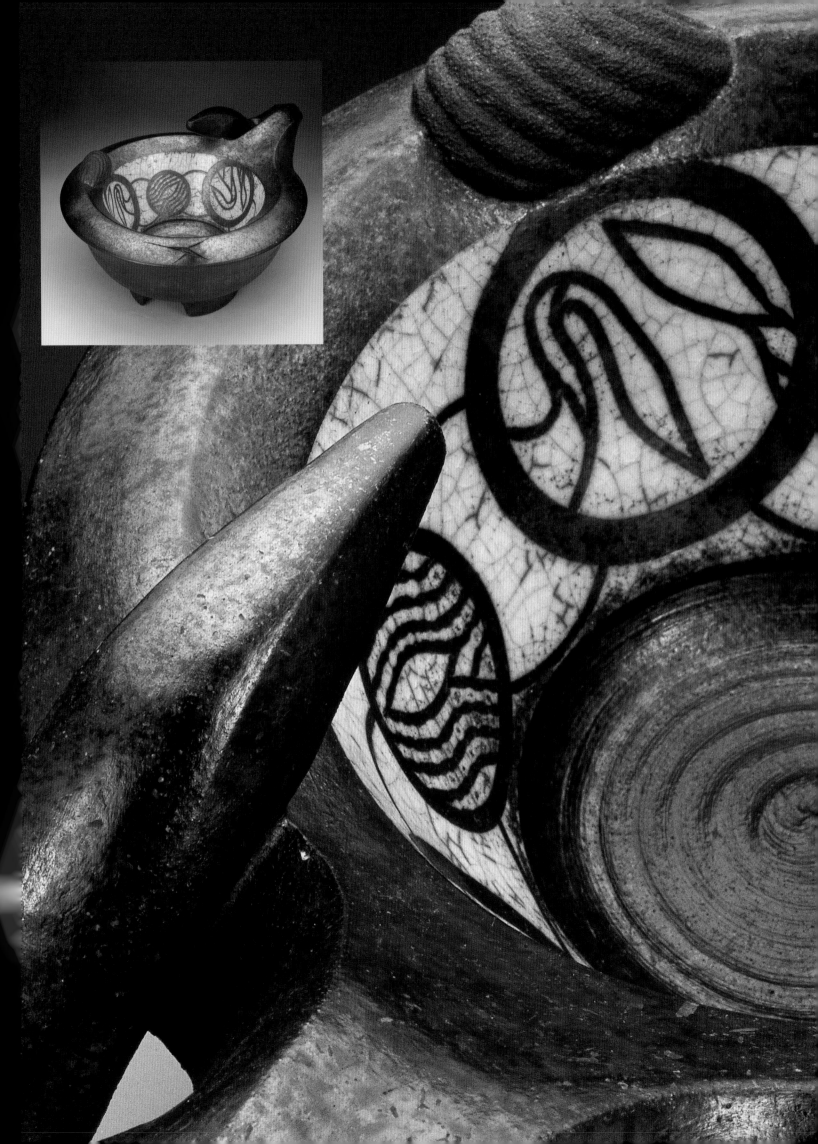

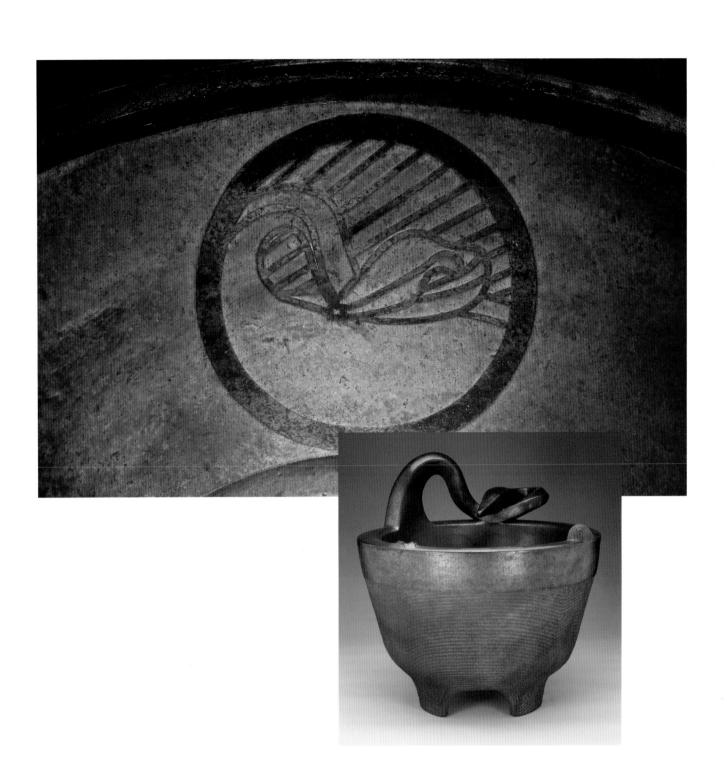

(above) *Waiting Posture,* double-walled caldron,
raku fired, 1998.
(facing page) From the *Guardian* series, double-walled bowl,
raku fired, 1998.

A CHRONOLOGY OF WORKS

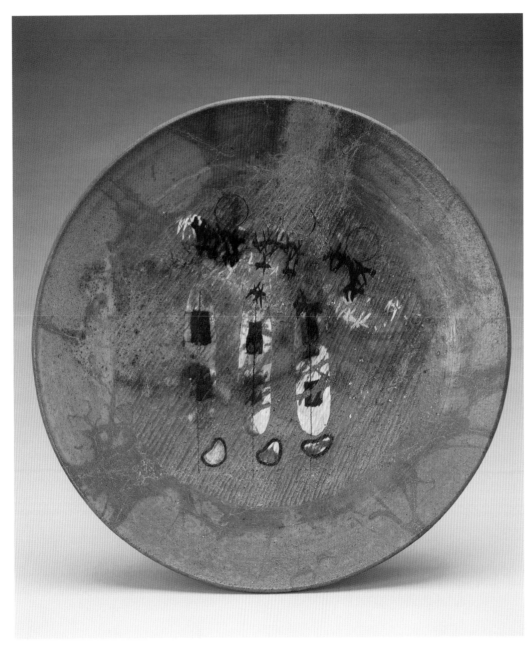

From the *Number 3* series
Platter form
Earthenware
1978
21″ d.
Collection of Deborah Milosevich
Lubbock, Texas

From the *Number 3* series
Platter form
Earthenware
1978
21" d.
Artist's collection

From the *Number 3* series
Platter form
Porcelain
1979
18" d.
Artist's collection

From the *Number 3* series
Platter form
Porcelain
1979
17″ d.
Artist's collection

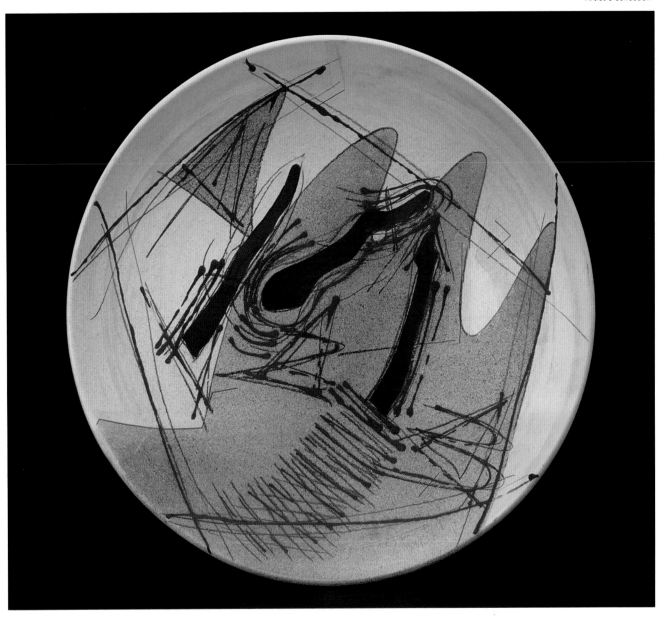

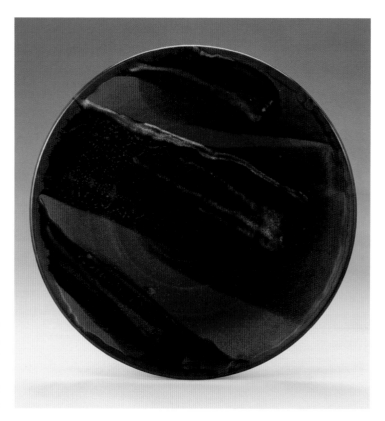

Platter
Stoneware
1979
16" d.
Collection of Dr. John and Linda Filippone
Lubbock, Texas

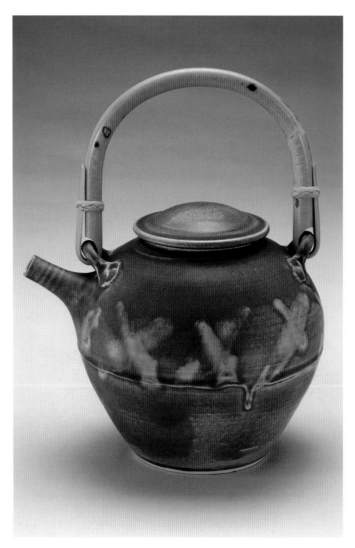

Tea pot
Porcelain
1979
8" h. × 7" w.
Collection of Robert and Dr. Lora Deahl
Lubbock, Texas

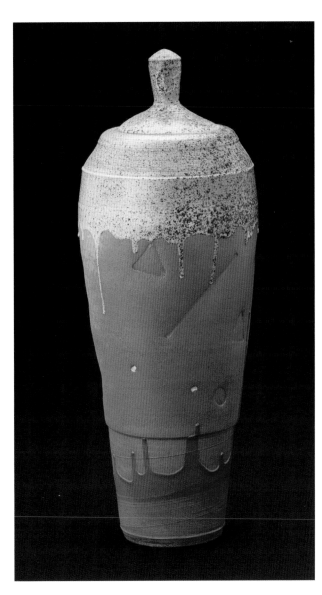

Covered jar
Stoneware
1980
25″ h. × 9″ w.
Collection of Dr. Elizabeth and Tom Sasser
Lubbock, Texas

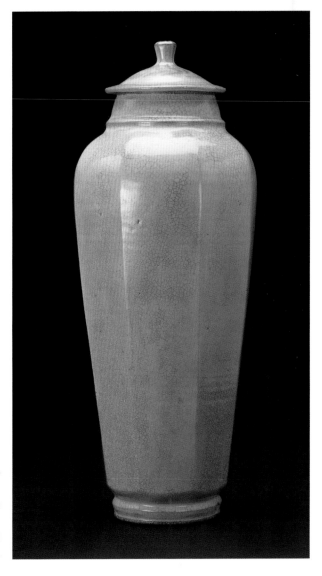

Covered jar
Stoneware
1980
24″ h. × 12″ w.
Collection of Dr. Orene Peddicord
Odessa, Texas

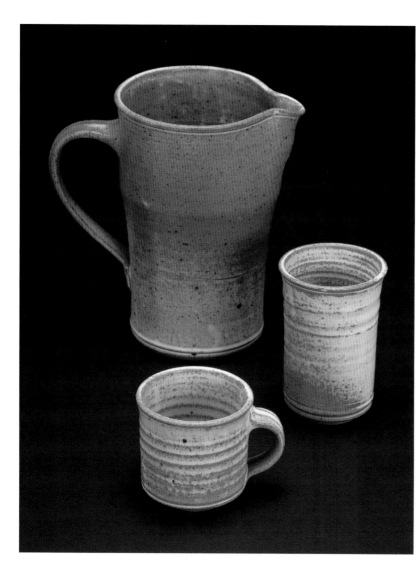

Pitcher, tumbler, and cup
Stoneware
1981
3 1/2″ h. × 4 1/2″ w. (cup)
5″ h. × 3 1/2″ w. (tumbler)
9″ h. × 8″ w. (pitcher)
Collection of Jeanie Jones
Lubbock, Texas

Dinnerware (one of each item)
Stoneware
1981
3 1/2″ h. × 4 1/2″ w. (cup)
10″ d. (large plate)
8 1/2″ d. (small plate)
Collection of Jeanie Jones
Lubbock, Texas

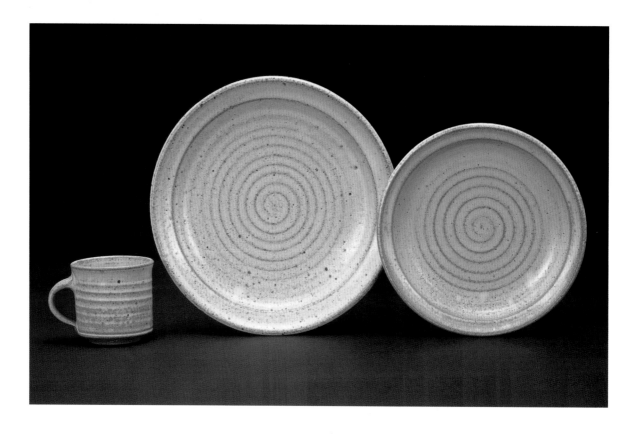

A M e d i t a t i o n o f F i r e

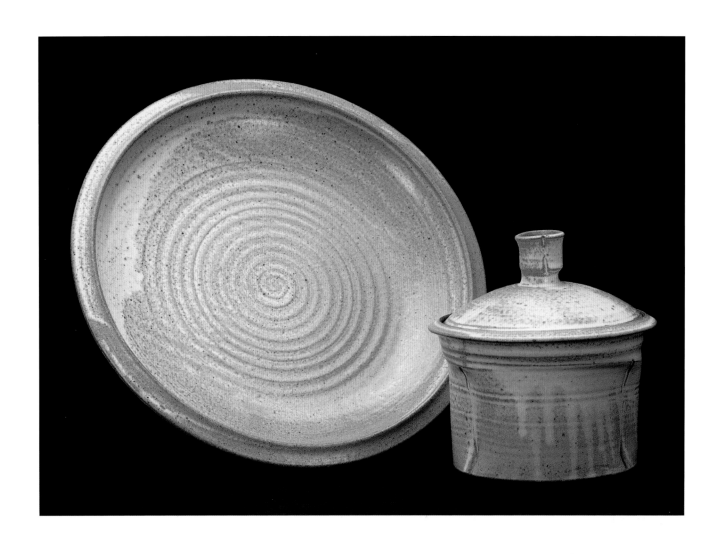

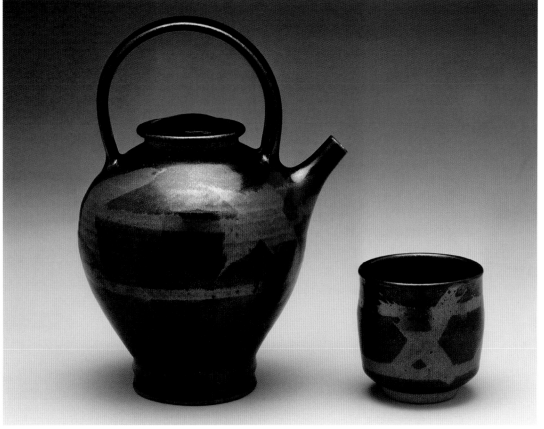

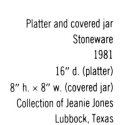

Platter and covered jar
Stoneware
1981
16″ d. (platter)
8″ h. × 8″ w. (covered jar)
Collection of Jeanie Jones
Lubbock, Texas

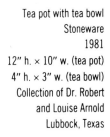

Tea pot with tea bowl
Stoneware
1981
12″ h. × 10″ w. (tea pot)
4″ h. × 3″ w. (tea bowl)
Collection of Dr. Robert
and Louise Arnold
Lubbock, Texas

CHRONOLOGY

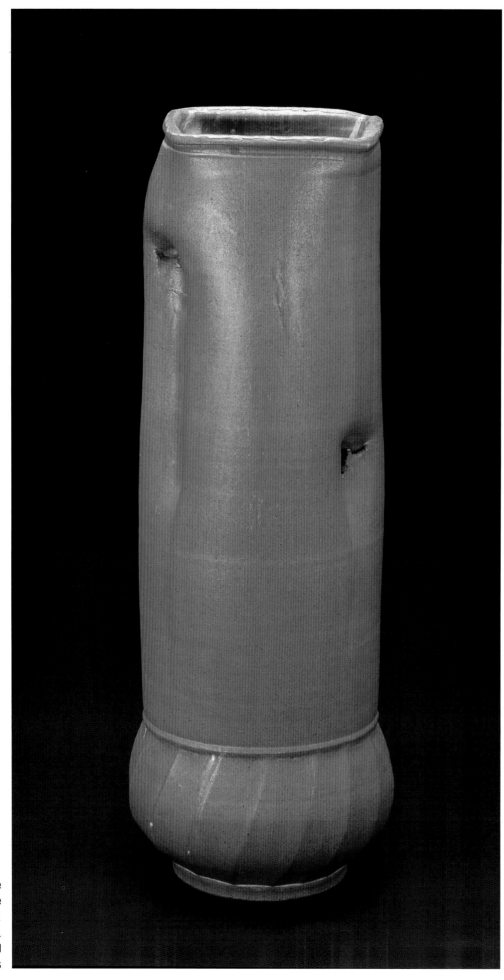

Vase
Stoneware
1981
24″ h. × 10″ w.
Collection of Dr. Robert and Louise Arnold
Lubbock, Texas

A Meditation of Fire

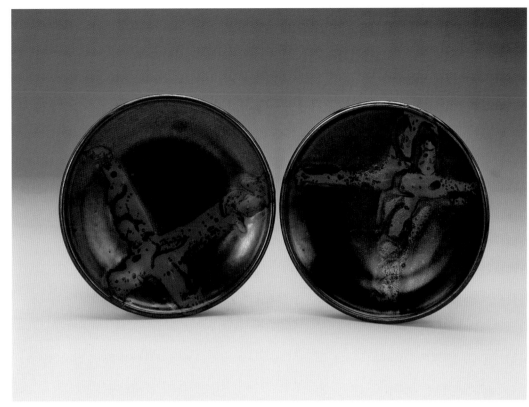

Small plates
Stoneware
1982
10" d.
Collection of Carl and Sue Minor
Lubbock, Texas

Covered dish
Stoneware
1982
8" h. × 11" w.
Collection of Jennifer and Toney
Greer
Lubbock, Texas

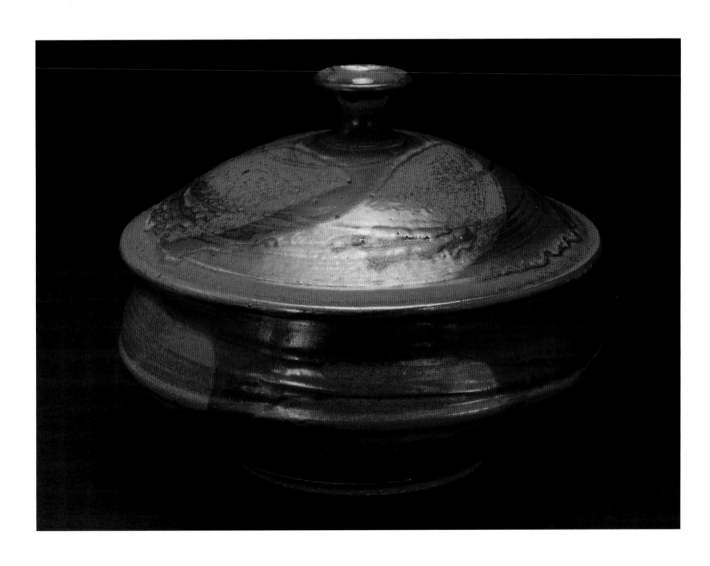

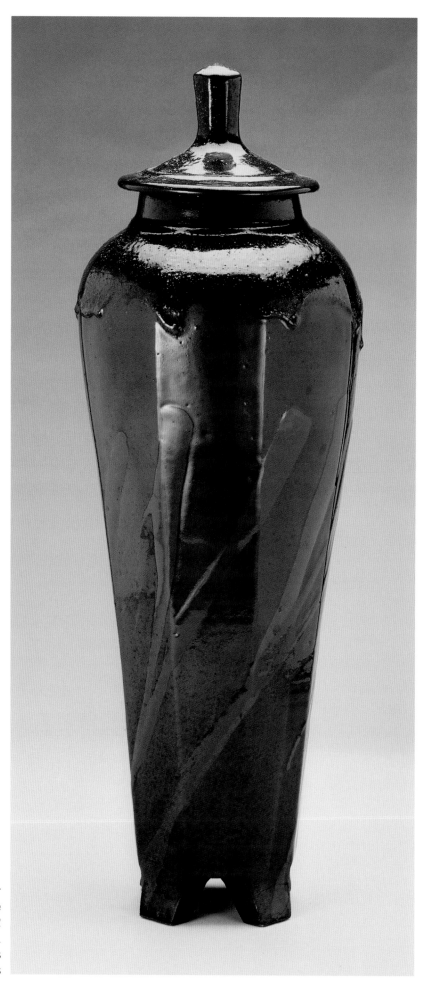

Covered jar
Stoneware
1982
29" h. × 10" w.
Collection of Joanna Mross
Lubbock, Texas

A Meditation of Fire

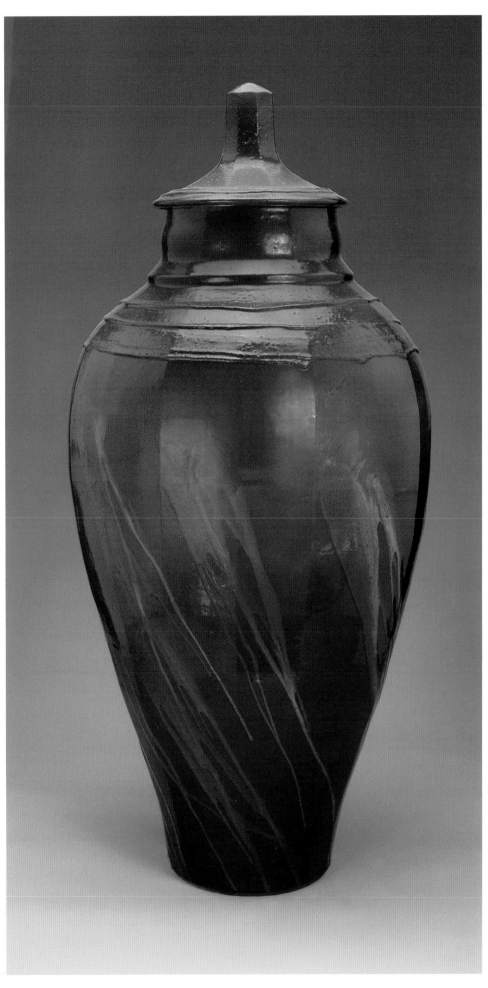

Covered jar
Stoneware
1982
43″ h. × 21″ w.
Collection of Tom and Bettie Mills
Scottsdale, Arizona

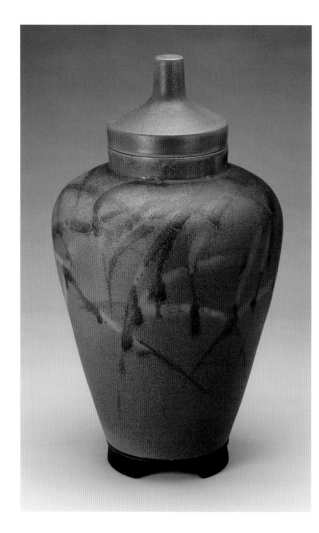

Covered jar
Stoneware
1982
23″ h. × 12″ w.
Collection of Dudley and Virginia Thompson
Lubbock, Texas

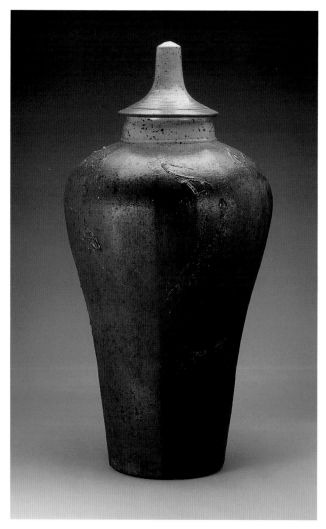

Covered jar
Stoneware
1983
39″ h. × 20″ w.
Collection of Kevin Taylor
Lubbock, Texas

A Meditation of Fire

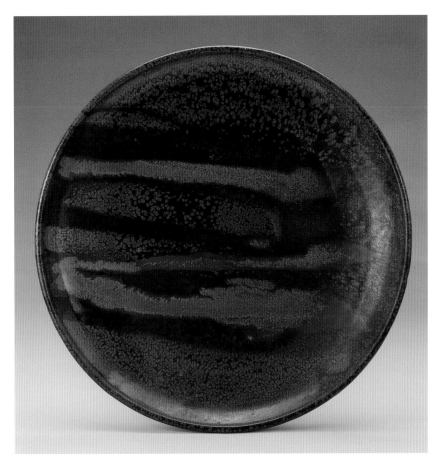

Platter
Stoneware
1983
16" d.
Collection of Future Akins
Lubbock, Texas

Double-walled bowl
Stoneware
1984
5" h. × 17" w.
Collection of Carl and Sue Minor
Lubbock, Texas

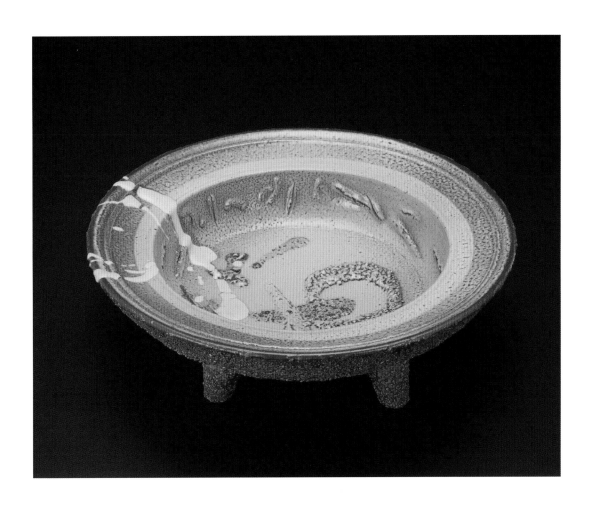

CHRONOLOGY

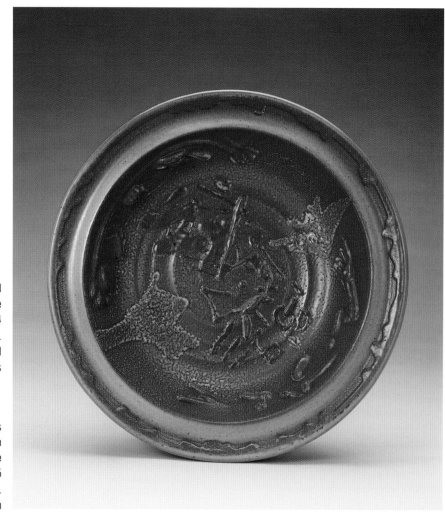

Double-walled bowl
Stoneware
1984
5″ h. × 16″ w.
Collection of Ashton and Susan Thornhill
Lubbock, Texas

From the *Horizon* series
Double-walled caldron
Stoneware
1985
11″ h. × 23″ w.
Artist's collection

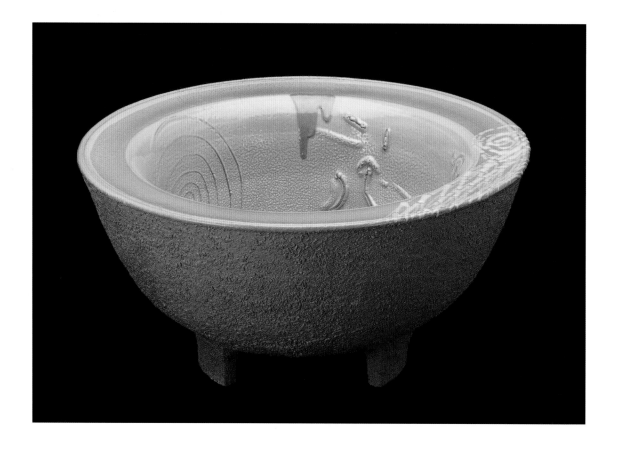

A Meditation of Fire

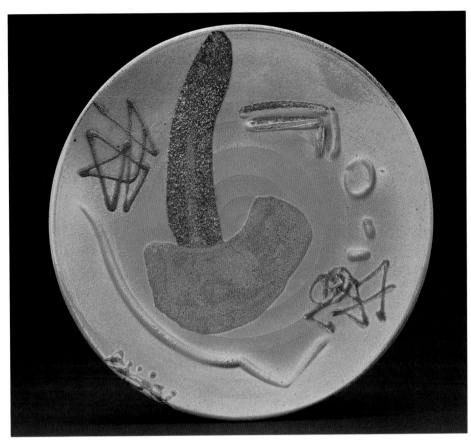

Platter form
Stoneware
1985
21" d.
Collection of Don Graf
Lubbock, Texas

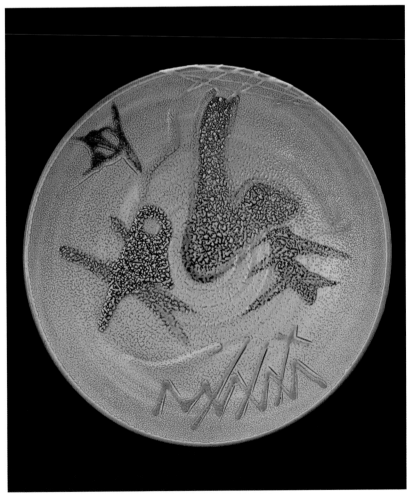

From the *Painted Desert* series
Platter form
Stoneware
1986
20" d.
Collection of Dudley and Virginia Thompson
Lubbock, Texas

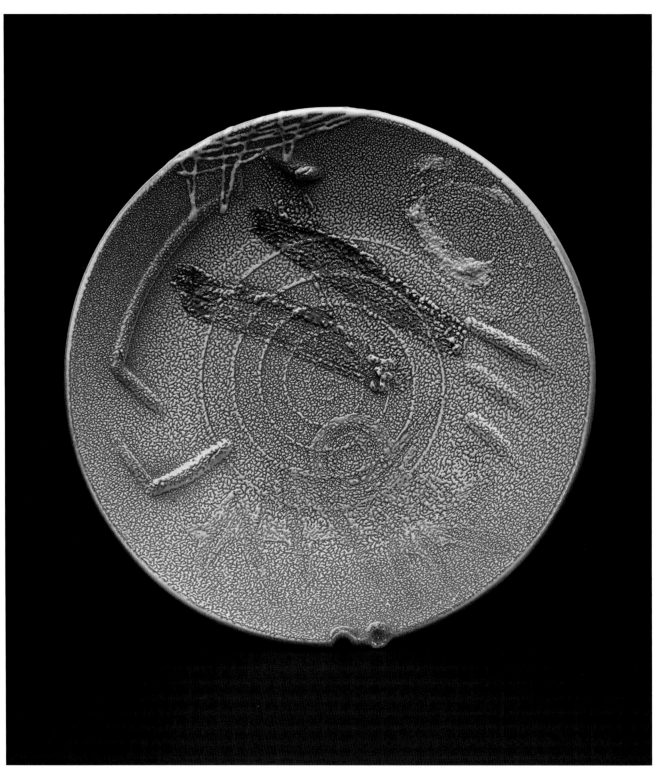

From the *Painted Desert* series
Platter form
Stoneware
1986
20″ d.
Artist's collection

A Meditation of Fire

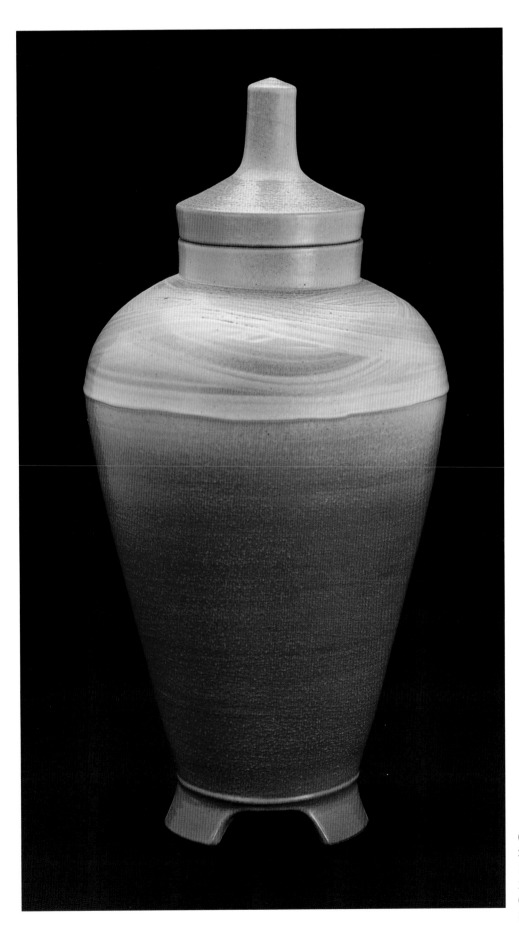

Covered jar
Stoneware
1987
25" h. × 13" w.
Collection of Michael and Pat Maines
Lubbock, Texas

Tea pot with tea bowls
Stoneware
1987
7" h. × 11" w. (tea pot)
3" h. × 3" w. (tea bowls)
Collection of Pam Spooner
Alpine, Texas

From the *Rattlesnake Canyon* series
Double-walled bowl
Stoneware
1988
15" h. × 19" w.
Collection of Cindy and David Sims
San Antonio, Texas

From the *Rattlesnake Canyon* series
Platter form
Stoneware
1988
18″ d.
Artist's collection

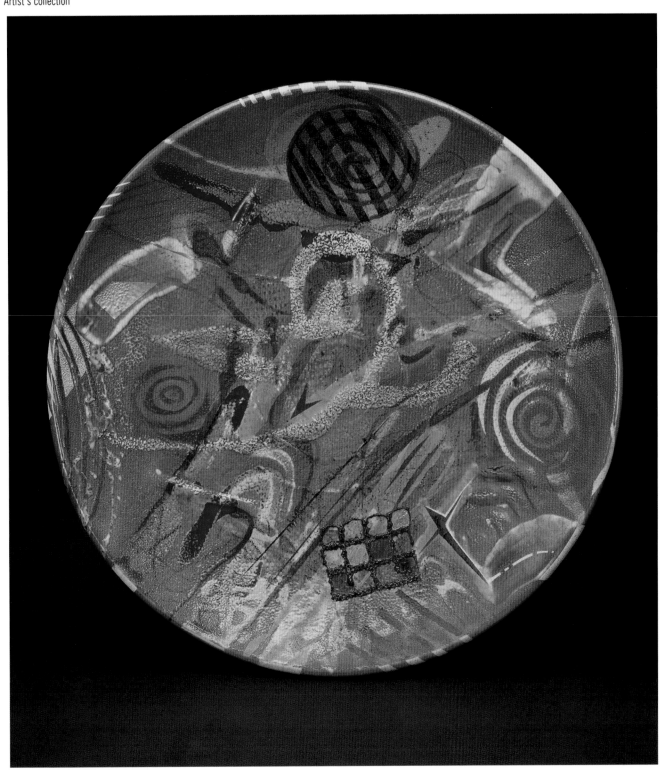

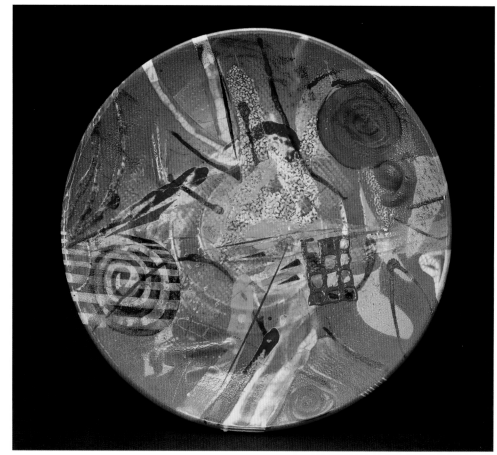

From the *Rattlesnake Canyon* series
Platter form
Stoneware
1988
18″ d.
Artist's Collection

From the *Rattlesnake Canyon* series
Double-walled bowl
Stoneware
1988
7″ h. × 15″ w.
Collection of Bea and Roger Garrison
Utopia, Texas

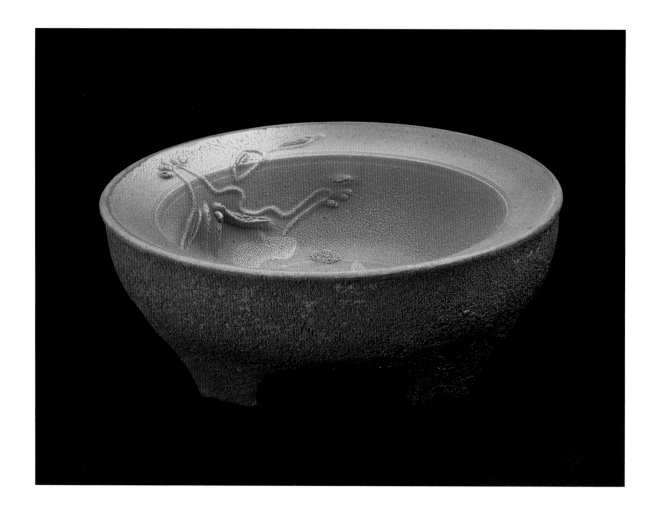

A Meditation of Fire

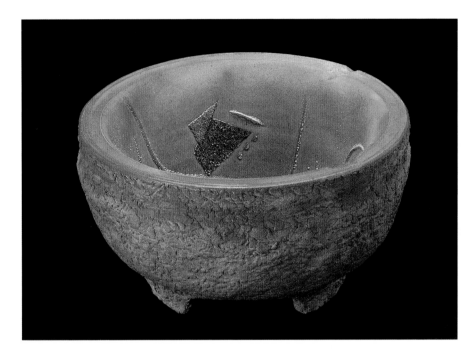

From the *Rattlesnake Canyon* series
Double-walled caldron
Stoneware
1988
12″ h. × 21″ w.
Collection of Robly Glover and Nancy Slagle
Lubbock, Texas

Zooming Man
Double-walled bowl
Stoneware
1988
6″ h. × 24″ w.
Collection of Erin Hayes
Yakima, Washington

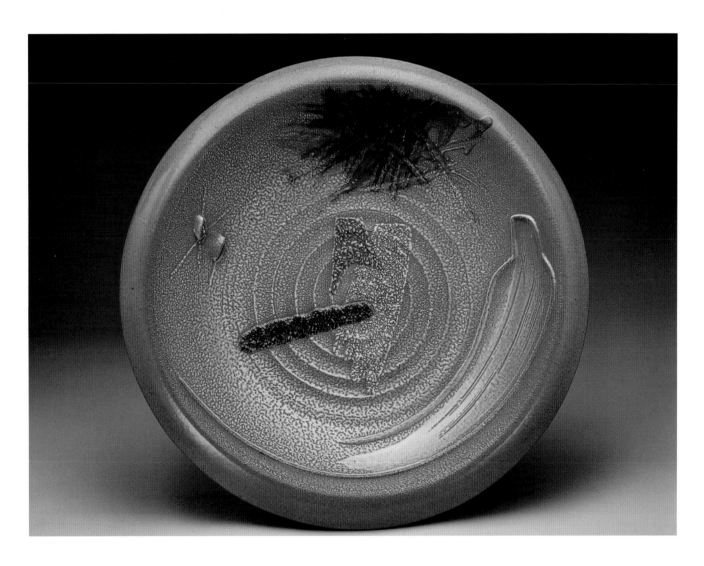

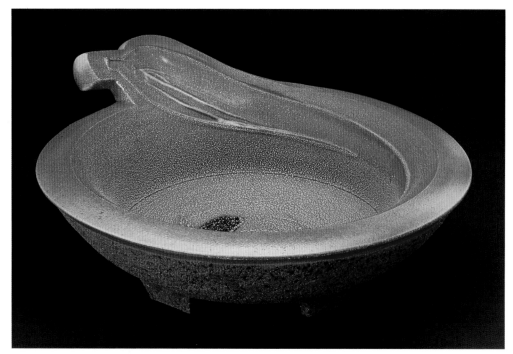

Zooming Man
Double-walled bowl
Stoneware
1989
9″ h. × 23″ w.
Collection of David and Maria Spies
Woodinville, Washington

Snake Crossing
Double-walled bowl
Stoneware
1989
12″ h. × 28″ w.
Artist's collection

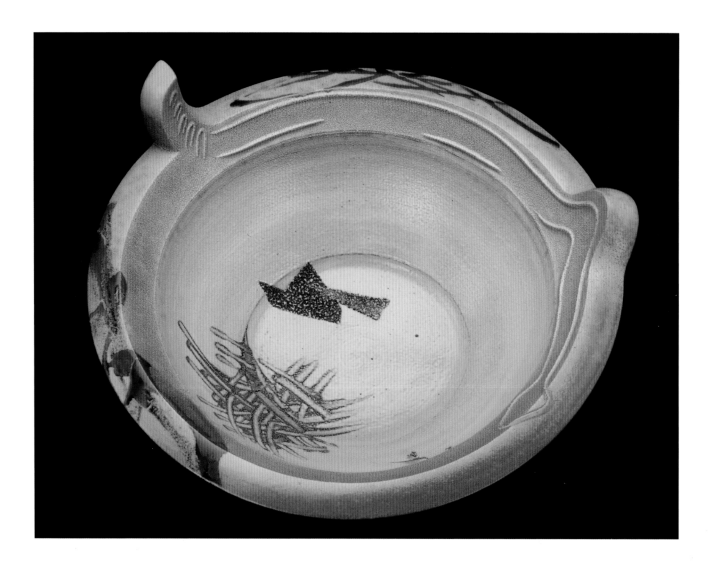

A Meditation of Fire

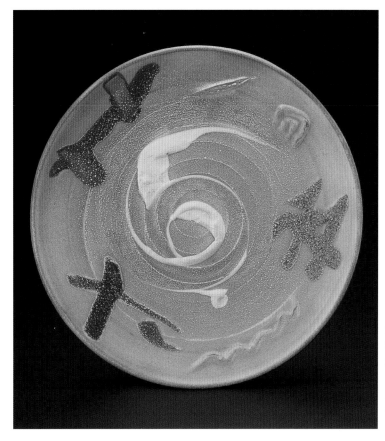

From the *Painted Desert* series
Platter form
Stoneware
1989
20" d.
Collection of Kippra Hopper
Lubbock, Texas

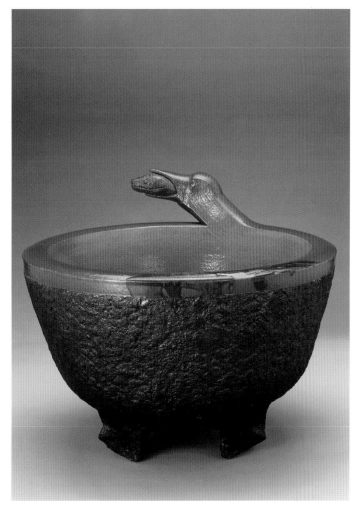

Bird/Snake Dream
Double-walled caldron
Stoneware
1990
17" h. × 22" w.
Artist's Collection

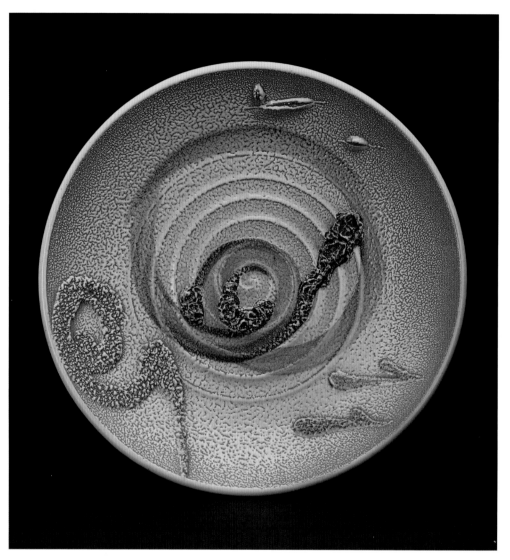

From the *Painted Desert* series
Platter form
Stoneware
1990
20″ d.
Artist's Collection

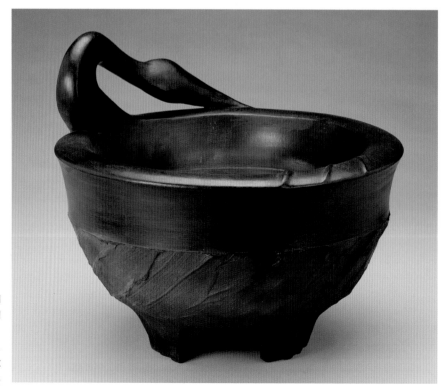

Double-walled bowl
Saggar fired
1991
15″ h. × 18″ w.
Collection of Dr. R. J. and Kathleen Wilcott
Lubbock, Texas

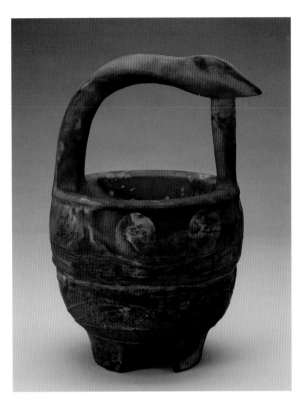

Bird Basket
Double-walled basket
Raku fired
1993
16" h. × 10" w.
Collection of Dr. John and Linda Filippone
Lubbock, Texas

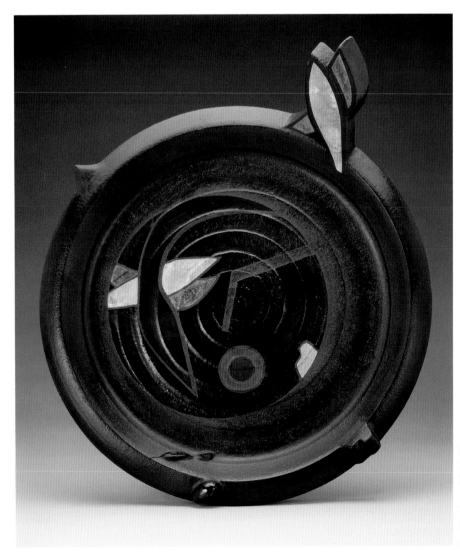

Rabbit/Bird
Double-walled platter form
Raku fired
1993
7" h. × 23" w.
Collection of Elizabeth Louden
Lubbock, Texas

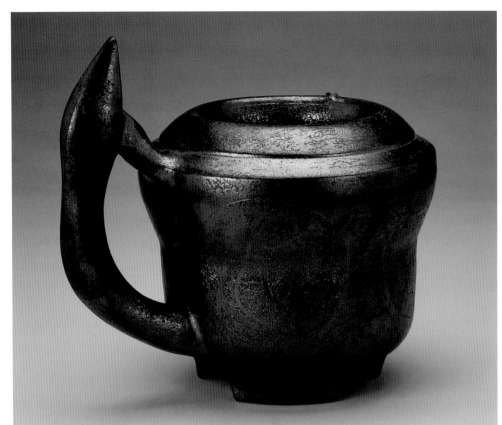

Double-walled bowl
Saggar fired
1993
12″ h. × 12″ w.
Collection of Joe and Melodie MacLean
Lubbock, Texas

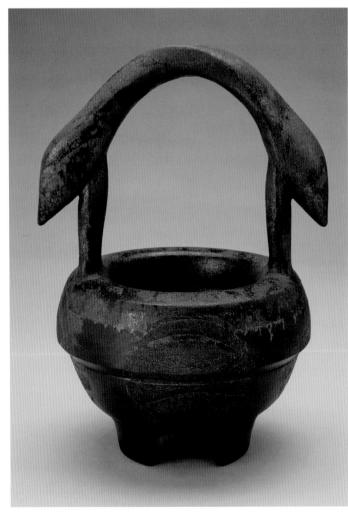

Bird Basket
Double-walled basket
Saggar fired
1994
16″ h. × 11″ w.
Collection of Linda Cullum
Lubbock, Texas

　　　　　　A Meditation of Fire

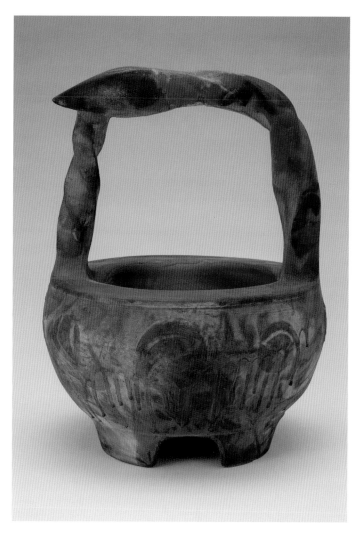

Bird Basket
Double-walled basket
Raku fired
1994
14″ h. × 12″ w.
Artist's collection

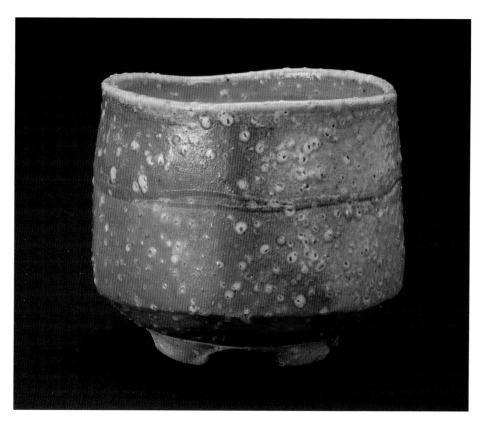

Tea bowl
Wood fired, Shigaraki clay
1994
4″ h. × 4″ w.
Artist's collection

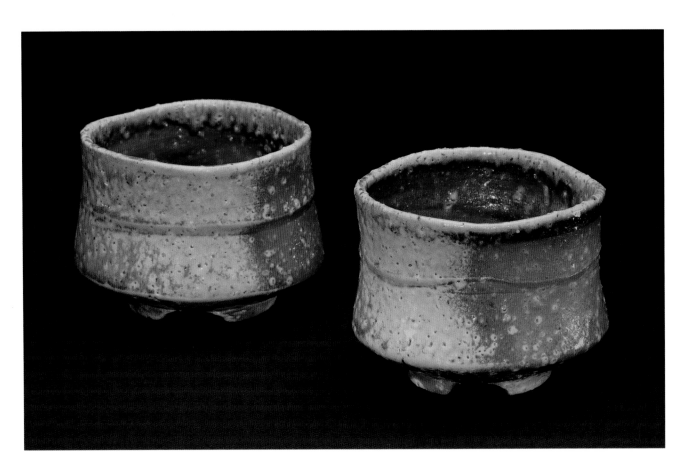

Tea bowls
Wood fired, Shigaraki clay
1994
3″ h. × 4″ w.
Artist's collection

A Meditation of Fire

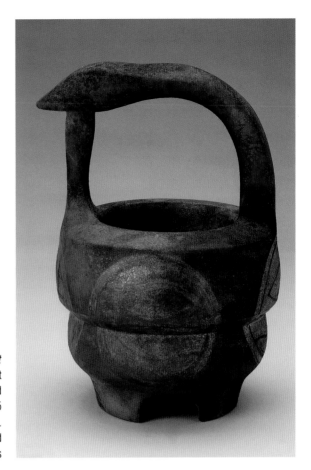

Bird Basket
Double-walled basket
Raku fired
1995
15″ h. × 10″ w.
Collection of Dr. Michael and Tigi Ward
Lubbock, Texas

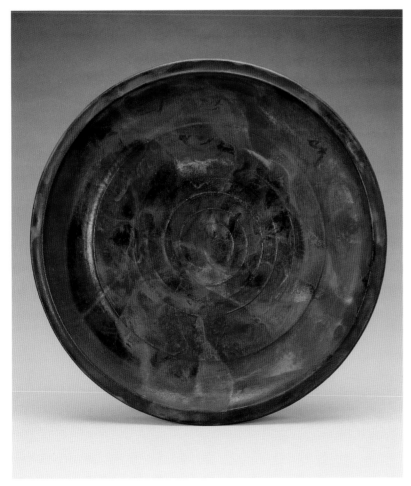

From the *Mask* series
Platter form
Raku fired
1995
23″ d.
Artist's collection

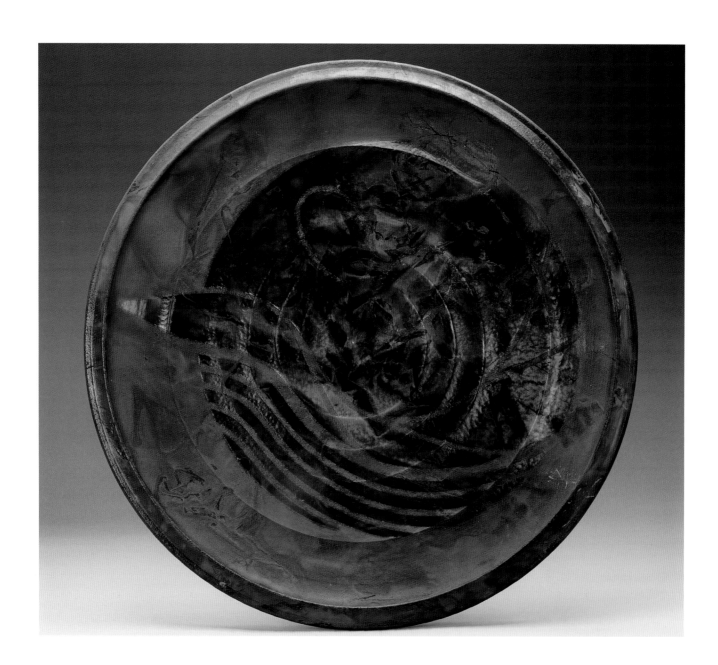

From the *Mask* series
Platter form
Raku fired
1995
23″ d.
Artist's collection

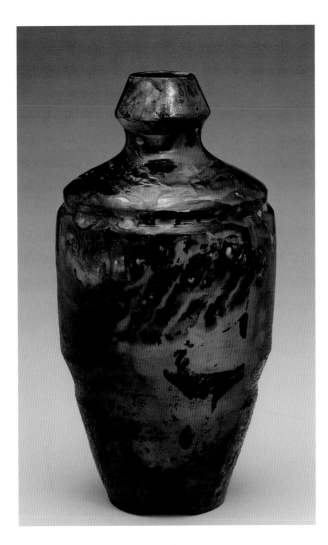

Bottle form
Raku fired
1995
11″ h. × 6″ w.
Collection of Drs. Lorenz and Margaret Lutherer
Lubbock, Texas

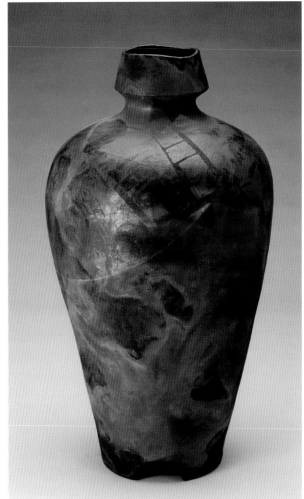

Bottle form
Raku fired
1995
24″ h. × 12″ w.
Collection of Patricia and Greg Phea
Lubbock, Texas

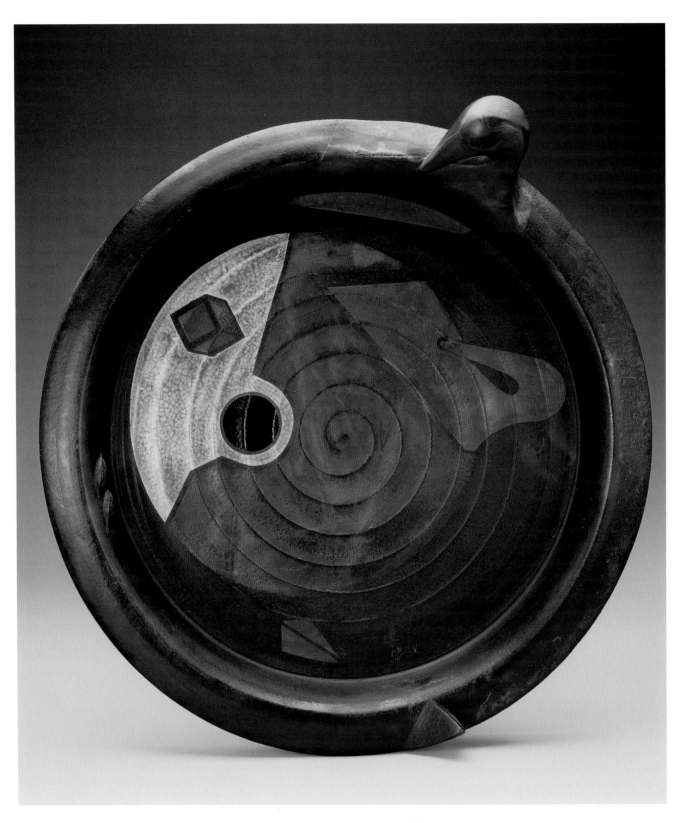

Sleeping Posture
Double-walled platter form
Raku fired
1995
7″ h. × 25″ w.
Collection of Texas Tech Museum

A Meditation of Fire

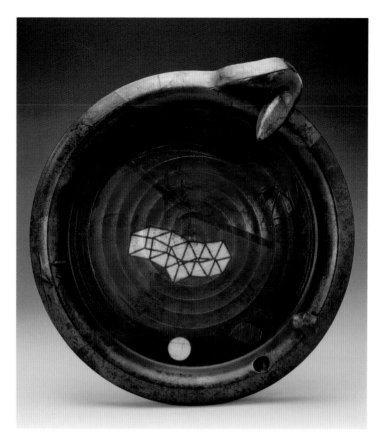

Intimidation Posture
Double-walled platter form
Raku fired
1995
6″ h. × 24″ w.
Artist's collection

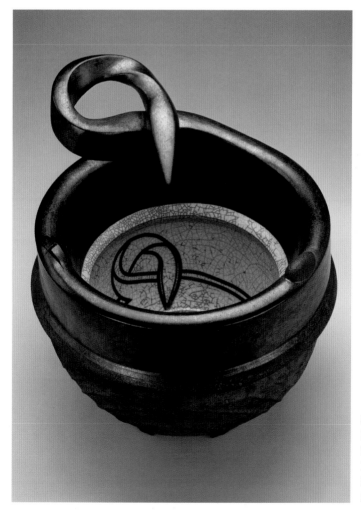

Sleeping Posture
Double-walled caldron
Raku fired
1995
20″ h. × 23″ w.
Artist's collection

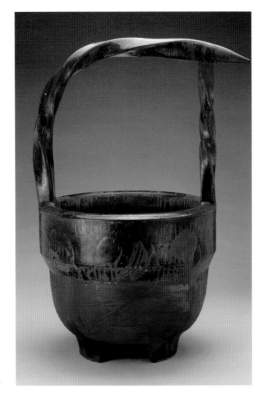

Bird Basket
Double-walled caldron
Raku fired
1995
36″ h. × 26″ w.
Artist's collection

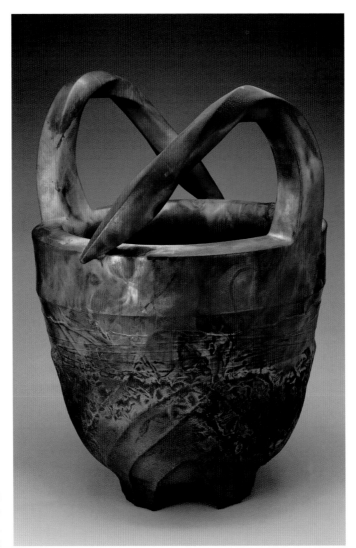

Preening Posture
Double-walled caldron
Raku fired
1995
31″ h. × 23″ w.
Artist's collection

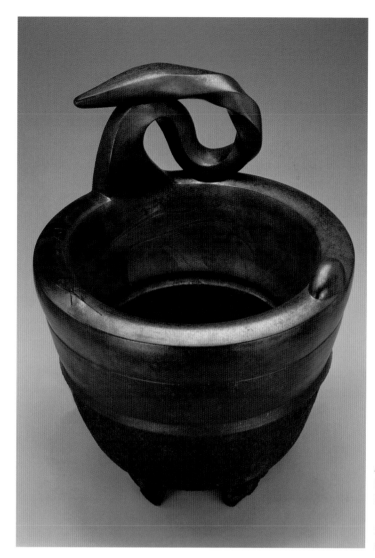

Ritual Display
Double-walled caldron
Raku fired
1995
27″ h. × 22″ w.
Collection of Texas Tech Museum

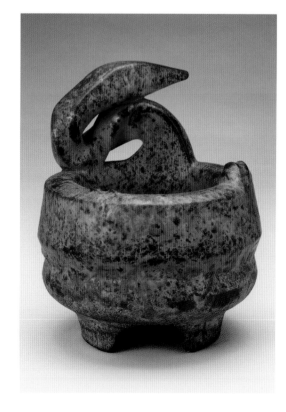

Ritual Display
Double-walled bowl
Raku fired
1995
9″ h. × 12″ w.
Collection of Dr. Gladys J. and Donald Whitten
Lubbock, Texas

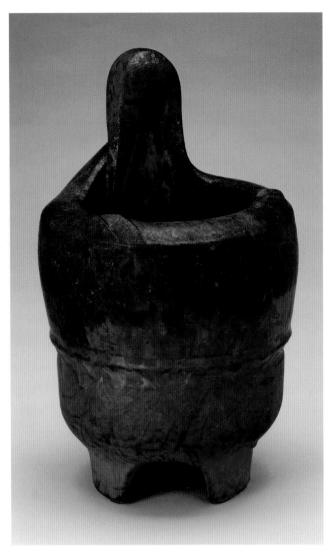

Sleeping Posture
Double-walled bowl
Raku fired
1995
14" h. × 10" w.
Collection of Ruth Marie
Lubbock, Texas

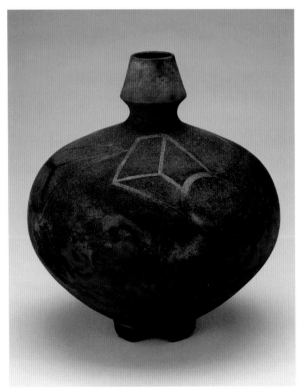

Bottle form
Raku fired
1995
11" h. × 9" w.
Collection of Dr. Robert and Louise
Arnold
Lubbock, Texas

A Meditation of Fire

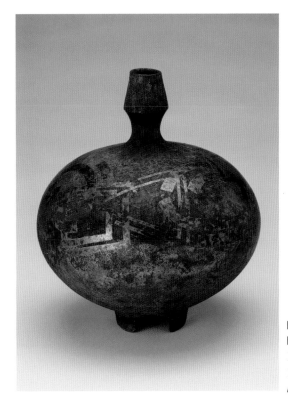

Bottle form
Raku fired
1995
11″ h. × 9″ w.
Artist's collection

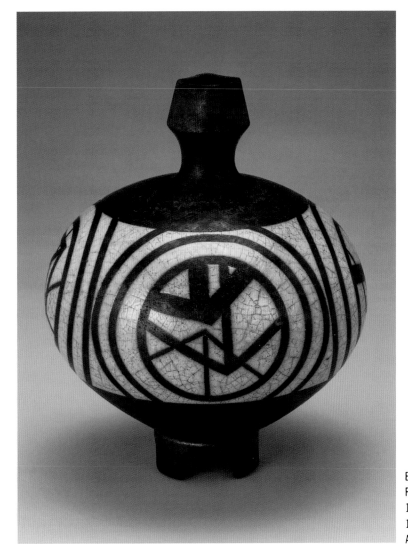

Bottle form
Raku fired
1995
11″ h. × 9″ w.
Artist's collection

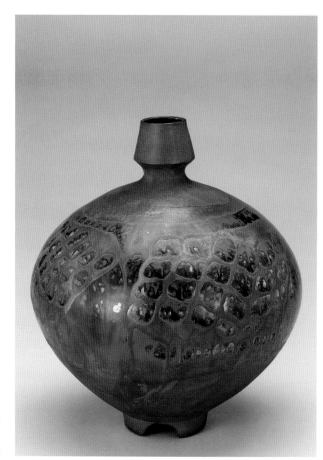

Bottle form
Raku fired
1995
11″ h. 9″ w.
Artist's collection

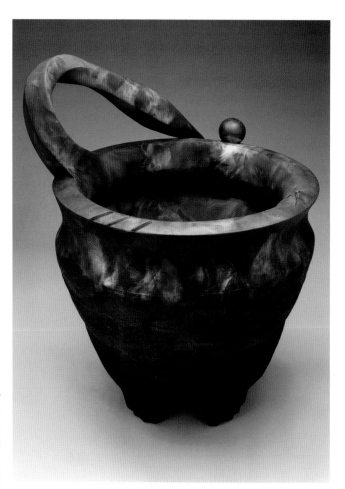

Preening Posture with Ball
Double-walled caldron
Raku fired
1995
27″ h. 24″ w.
Artist's collection

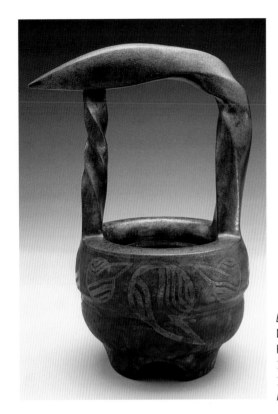

Bird Basket
Double-walled basket
Raku fired
1995
15″ h. 10″ w.
Artist's collection

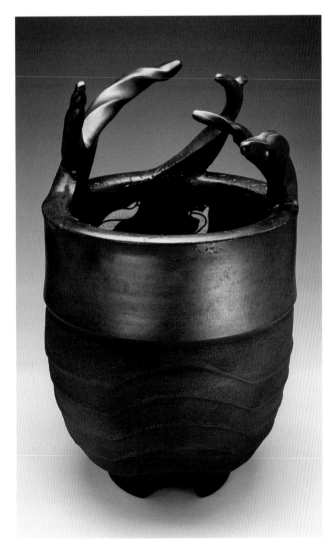

From the *Guardian* series
Double-walled caldron
Raku fired
1996
27″ h. 17″ w.
Artist's collection

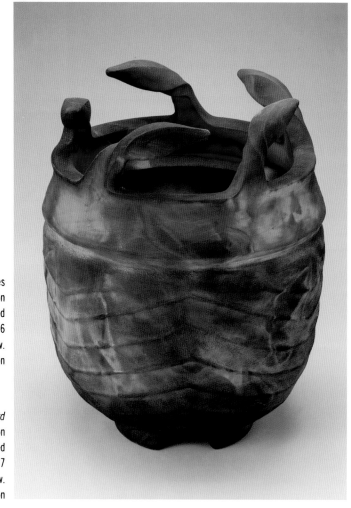

From the *Guardian* series
Double-walled caldron
Raku fired
1996
25″ h. × 20″ w.
Artist's collection

Knight/Night Bird
Double-walled caldron
Saggar fired
1997
17″ h. × 28″ w.
Artist's collection

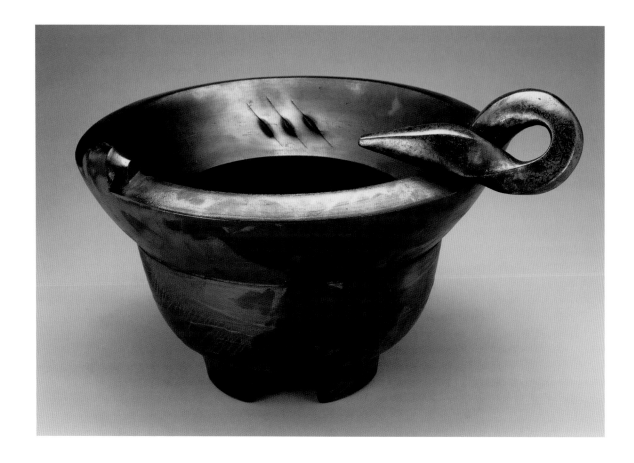

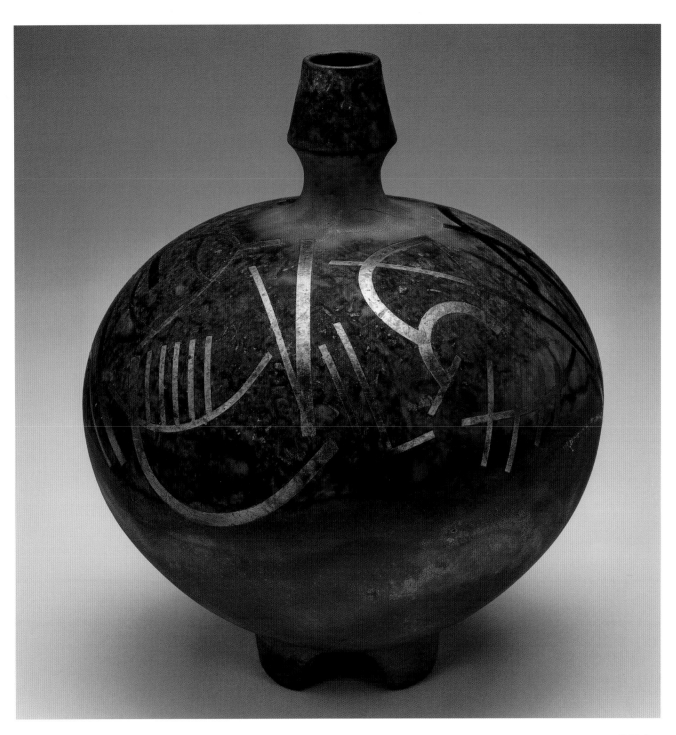

Bottle form
Raku fired
1997
11" h. × 9" w.
Collection of Dudley and Virginia Thompson
Lubbock, Texas

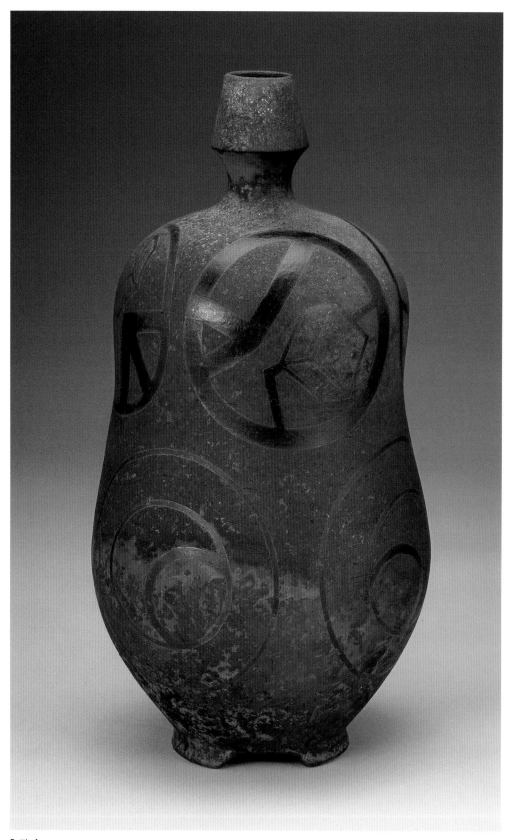

Bottle form
Raku fired
1997
15″ h. × 8″ w.
Artist's collection

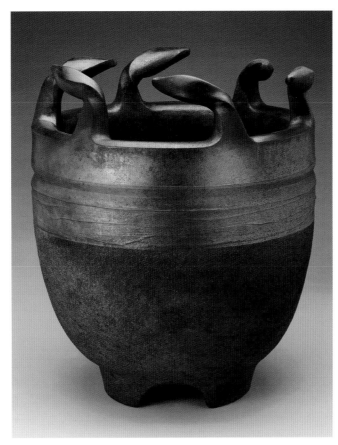

Guardians
Double-walled caldron
Raku fired
1998
25″ h. × 20″ w.
Artist's collection

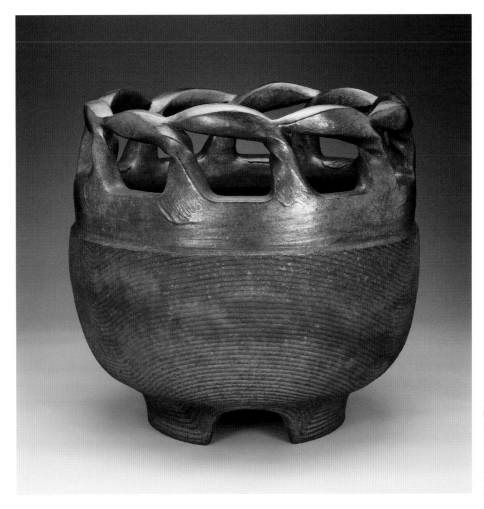

Communion
Double-walled caldron
Raku fired
1998
21″ h. × 21″ w.
Artist's collection

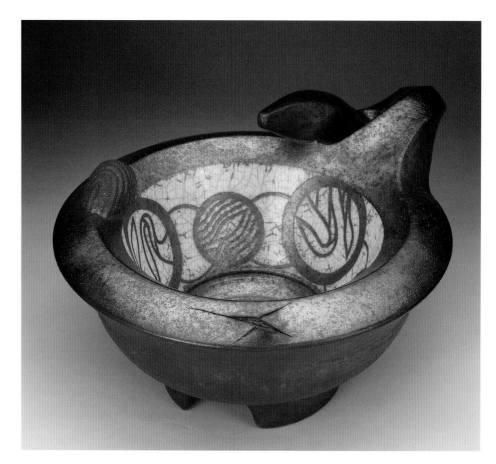

From the *Guardian* series
Double-walled bowl
Raku fired
1998
9" h. × 19" w.
Artist's collection

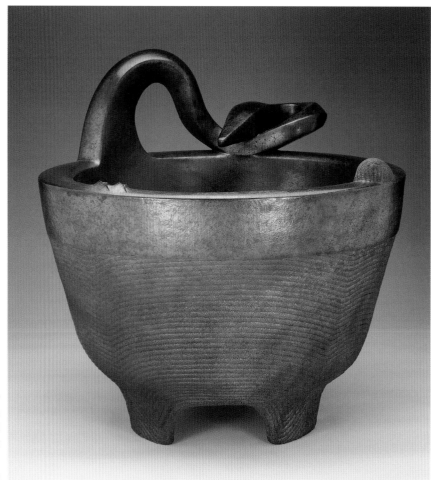

Waiting Posture
Double-walled caldron
Raku fired
1998
23" h. × 27" w.
Artist's collection

SELECTED EXHIBITION HISTORY

Exhibitions sponsored by the National Council on Education for the Ceramic Arts are indicated by (NCECA).

1978

Group Exhibition: *Five Texas Artists*, Garden and Arts Center, Lubbock, Texas.
Solo Exhibition: *New Works*, The O'Neil Gallery, YWCA, Lubbock, Texas.

1979

Group Exhibition: *Clay on the Wall*, Garden and Arts Center, Lubbock, Texas.
Two-Person Exhibition (with May Stevens): Texas Tech University, Architecture Gallery, Lubbock, Texas.

1980

Group Exhibition: *College Artist/Instructors*, Hobbs New Mexico Junior College, Hobbs, New Mexico.
Juried Exhibition: *Great Fall's National*, Fall River Museum, Fall River, Massachusetts (brochure).
Group Exhibition: *Clay Az Art III*, Northern Arizona University, Flagstaff, Arizona.
Juried Exhibition: *Marietta National "80,"* Marietta College, Marietta, Ohio (brochure).
Group Exhibition: Carlsbad Fine Art Museum, Carlsbad, New Mexico.
Group Exhibition: *Inside Texas Borders, in the South Texas Artmobile*, Corpus Christi State University, Corpus Christi, Texas (catalogue).

1981

Group Exhibition: *Instructors of Clay*, Texas Tech University, Architecture Gallery, Lubbock, Texas.
Group Exhibition: *Clay Az Art IV*, Northern Arizona University, Flagstaff, Arizona.
Group Exhibition: *Roth Art Series*, College of the Southwest, Hobbs, New Mexico (brochure).
Two-Person Exhibition (with Sara Waters): East Texas State University, Commerce, Texas.

1982

Group Exhibition: *Oso Bay Biennial*, Corpus Christi State University, Corpus Christi, Texas.
Two-Person Exhibition (with Ashton Thornhill): *New Works*, Lubbock Lights Artists Cooperative, Lubbock, Texas (brochure).
Group Exhibition: Associates Plus Gallery of Fine Arts, Dallas Texas.

1983

Group Exhibition: *Drawings on Clay,* Northern Arizona University, Flagstaff, Arizona.
Solo Exhibition: *New Works,* New Mexico Junior College, Hobbs, New Mexico.
Solo Exhibition: *New Works,* Amarillo Art Center, Amarillo, Texas.
Group Exhibition: *Clay in New Mexico,* University of New Mexico Museum in Albuquerque, Albuquerque, New Mexico (catalogue).
Group Exhibition: *Clay Works from the Mackenzie Terrace Pottery Center,* Texas Tech University Museum, Lubbock, Texas.

1984

Group Exhibition: *31 Texas Artists,* Annie Hawkins Gallery, Houston, Texas.
Group Exhibition: *The Lakeside Group,* Lill Street Gallery, Chicago, Illinois.
Group Exhibition: *Chicago International Art Exposition,* Chicago, Illinois, (represented by Lakeside Studios).
Two-Person Exhibition (with Sara Waters): Lakeside Studios, Lakeside, Michigan.
Two-Person Exhibition (with Sara Waters): New Mexico Junior College, Hobbs, New Mexico.

1985

Group Exhibition: *Texas Designers Craftsmen,* Texas Tech Museum, Lubbock, Texas.
Group Exhibition: *Chicago International Art Exposition,* Chicago, Illinois, (represented by Lakeside Studio).

1986

Group Exhibition: *Texas Clay,* San Antonio Municipal Auditorium, San Antonio, Texas (NCECA).
Group Exhibition: *Transposition/Collaborations,* San Antonio Art Institute, San Antonio, Texas (NCECA) (brochure).
Group Exhibition: *Creighton Clay Invitational,* Creighton University, Omaha, Nebraska.
Group Exhibition: *Yuma Symposium 7,* Arizona Western College, Yuma, Arizona.
Solo Exhibition: *Horizons,* Daugherty Art Center, Austin, Texas.

1987

Two-Person Exhibition (with Nathan Jones): Wichita Falls Museum, Wichita Falls, Texas.
Group Exhibition: Handcrafters Gallery, Santa Fe, New Mexico.
Group Exhibition: *Voices,* Syracuse University Folk Arts Center, Syracuse, New York (NCECA).

1988

Group Exhibition: *New Visions from Rattlesnake Canyon,* Lubbock Fine Arts Center, Lubbock, Texas.
Group Exhibition: *Concepts in Clay,* Abilene Fine Arts Museum, Abilene, Texas (brochure).
Group Exhibition: *The Collector's Treasures,* The Texas Tech University Museum, Lubbock, Texas.

1989

Group Exhibition: *Ceramic Tradition,* Contemporary Art Center, Kansas City, Missouri (NCECA) (brochure).
Group Exhibition: *New Visions,* Sul Ross University, Alpine, Texas.
Group Exhibition: *Yuma Art Symposium, 10 Years After,* Arizona Western College, Yuma, Arizona.
Solo Exhibition: *Horizons,* Carver Art Center, San Antonio, Texas.
Group Exhibition: *New Visions from Rattlesnake Canyon,* Witte Museum, San Antonio, Texas.

Group Exhibition: *Contemporary Ceramics,* William Campbell Contemporary, Fort Worth, Texas.
Solo Exhibition: *Horizons,* Sul Ross University, Alpine, Texas.
Group Exhibition: Milagro de Taos Gallery, Taos, New Mexico.

Juried Exhibition: *Black Creativity,* Museum of Science and Industry, Chicago, Illinois.
Group Exhibition: *Le Grand Bal Masque des Beaux Arts, Art Acquisition Fund Auction,* Dallas Museum of Art, Dallas, Texas.
Group Exhibition: *Diversity in Clay,* Herkimer County Community College, Herkimer County, New York.
Group Exhibition: *Diversity in Clay,* Art Center/Old Forge, New York (brochure).
Group Exhibition: *Rejoice,* Lubbock Fine Arts Center, Lubbock, Texas (catalogue).
Group Exhibition: *Creative Partners,* Sewall Art Gallery, Rice University, Houston, Texas.

Group Exhibition: *The Present Clay Presence–Informed by the Past,* University of North Texas, Denton, Texas.
Two-Person Exhibition (with Jack Thompson): *North Meets South,* Sande Webster Gallery, Philadelphia, Pennsylvania (NCECA) (brochure).
Group Exhibition: *Clay Heritage: African American Ceramics,* The Afro-American Historical and Cultural Museum, Philadelphia, Pennsylvania (NCECA) (catalogue).
Group Exhibition: *Black Creativity in Texas,* Lubbock Fine Art Center, Lubbock, Texas (catalogue).
Solo Exhibition: *New Works,* California University of Pennsylvania, California, Pennsylvania.

Solo Exhibition: *Pots Made of Memories,* Southwest Craft Center, San Antonio, Texas.
Group Exhibition: *Messages from Home, Color Network,* Fuehwirt Designs, San Diego, California (NCECA).
Group Exhibition: *Texas Clay II,* Stephen F. Austin State University, Nacogdoches, Texas (brochure).
Group Exhibition: *Cups–National Invitational,* Artworks Gallery, Seattle, Washington.
Group Exhibition: *Before There Were Borders, Beyond Imaginary Lines,* The Gallery at the Rep, Santa Fe, New Mexico.
Group Exhibition: *Barro Sin Fronteras–Clay Without Borders,* El Paso, Texas (brochure).
Solo Exhibition: *New Works,* Craft Guild of Dallas, Dallas, Texas.

Solo Exhibition: *Pots Made of Memories,* Manchester Craftsmen's Guild, Pittsburgh, Pennsylvania.
Group Exhibition: *African-American Craft National,* Kentucky Art and Craft Gallery, Louisville, Kentucky.
Solo Exhibition: *Remembrance,* Kalamazoo Institute of Art, Kalamazoo, Michigan.
Group Exhibition: Middle Tennessee State University, Murfreesboro, Tennessee.
Group Exhibition: *Uncommon Beauty In Common Objects,* The American Craft Museum, New York, New York (catalogue).
Group Exhibition: *Uncommon Beauty In Common Objects,* National Afro-American Museum and Cultural Center, Wilberforce, Ohio (catalogue).

Group Exhibition: *Uncommon Beauty In Common Objects,* The Renwick Gallery, National Museum of American Art, Smithsonian Institution, Washington, D.C. (catalogue).

Two-Person Exhibition (with Sara Waters): The University of Texas of the Permian Basin, Odessa, Texas (brochure).

Group Exhibition: *Keepers of the Flame: Ken Ferguson's Circle,* The Kemper Museum of Contemporary Art and Design, The Kansas City Art Institute, Kansas City, Missouri (catalogue).

Solo Exhibition: *New Works,* Southwest Texas State University Library, San Marcos, Texas.

Group Exhibition: *Exhibition of Works Born at the Park from the Artists in Residence,* The Shigaraki Ceramic Cultural Park, Shigaraki, Japan (brochure).

Group Exhibition: *The White House Collection of American Crafts,* National Museum of American Art, The Smithsonian Institution, Washington, D.C. (catalogue).

Group Exhibition: *Contained/Uncontained: Four Clay Artists,* African American Museum, Dallas, Texas (brochure).

Group Exhibition: *The White House Collection of American Crafts,* The American Craft Museum, New York, New York (catalogue).

Group Exhibition: *The White House Collection of American Crafts,* The Memorial Art Gallery of the University of Rochester, in Rochester, New York (catalogue).

Group Exhibition: *The White House Collection of American Crafts,* Los Angeles County Museum of Art, Los Angeles, California (catalogue).

Two-Person Exhibition (with Rick Dingus): Oklahoma State University, Stillwater, Oklahoma.

Group Exhibition: *The White House Collection of American Crafts,* The Museum of Fine Arts, Springfield, Massachusetts (catalogue).

Group Exhibition: *Uniqueness From The Hand,* University of Texas in San Antonio, Art Gallery, San Antonio, Texas.

Group Exhibition: *Whitewater Invitational,* University of Wisconsin, Whitewater, Wisconsin.

Solo Exhibition: *Remembrance,* Baylor University, Waco, Texas.

Group Exhibition: *The White House Collection of American Crafts,* Tampa Museum of Art, Tampa, Florida (catalogue).

Group Exhibition: *The White House Collection of American Crafts,* The Colby College Museum of Art, Waterville, Maine (catalogue).

Solo Exhibition: *Images of Our Times,* Galveston College, Galveston, Texas.

Group Exhibition: *Texas Tech University 75th Anniversary Exhibition: Faculty and Alumni works from the Museum Collection,* Texas Tech University Museum, Lubbock, Texas.

Solo Exhibition: *Remembrance,* Wayland Baptist University, Plainview, Texas.

Group Exhibition: *Ceramics Celebration "98,"* Roswell Museum and Art Center, Roswell, New Mexico.

Group Exhibition: *Texas Tech University Invitational,* Texas & Pacific Terminal, Fort Worth, Texas (NCECA).

Group Exhibition: *Texas Fireworks: On and Off the Wall,* Dallas Visual Art Center, Dallas, Texas (NCECA).

Group Exhibition: *To Have and To Hold,* Irving Arts Center, Irving, Texas (NCECA) (catalogue).

Group Exhibition: *Claymakers: Clay Under The X - 8 Texas Artists,* Arlington Museum of Art, Arlington, Texas (NCECA) (brochure).

SELECTED BIBLIOGRAPHY

ARTICLES AND BOOKS

Bloom, Taylor. "Lubbock Collects Tech." *Caprock Sun, Entertainment, Cultural and Arts Magazine* (January-February 1998):8-9.

"Cover Page." *Key Magazine* San Antonio (May 1989).

Fairbanks, Jonathan, and Angela Fina, editors. *The Best of Pottery.* Rockport, Mass.: Quarry Books, 1996.

"Gallery Clay." *American Craft* (April-May 1993):76.

Goddard, Dan R., "A New Light on Ancient Art," *San Antonio Express News* (May 21, 1989):1-H, 5-H.

Haggard, Lynn. "Review." *Times Record News* Wichita Falls (November 2, 1987):C1-C2.

Hasting, Deborah. "Southern Pottery as Art." *Southern Living Magazine* (January 1984):94.

"To Have and To Hold." *Ceramics Monthly* (June-July-August 1998): 75.

Hopper, Kippra D. "Magic & Fire." *VISTAS: Texas Tech Research Magazine,* vol. 3, no.2 (Summer 1993):15-19.

"James C. Watkins," *Ceramics Monthly* (October 1981):36-37.

"James Watkins." *Ceramics Monthly* (October 1986):22-24.

Kemper·Museum of Contemporary Art and Design. *Keepers of the Flame.* Kansas City, Mo.: Kansas City Art Institute, 1995, catalogue.

Krantz, Les. *The Texas Art Review.* Houston: Gulf Publishing,1982.

Lance, Mary, "Pots Made of Memories: Near-death Experience Turns Life into Magic," *San Antonio Light-VIVA* (January 13, 1993): C1, C4.

Lubbock Fine Arts Center. *Black Creativity in Texas, Visual Vanguards.* Lubbock: Printech Production, 1992, catalogue.

McCune, Patrick. "Que Pasa?" *Yuma Daily Sun* (February 23, 1989): 11.

McKey, Nola. "Culture on the Caprock." *Texas Highways, The Travel Magazine of Texas* (April 1998): 4-13.

Martin, Patricia D. "Art and Literature" *Drum Beat* (June 1988):28-29.

Merino, Tony. "Art out of Frugality: The Work of James Watkins." *Clay Times, The Journal of Ceramic Trends & Techniques* (July-August 1998):27-28.

Monroe, Michael W., Barbaralee Diamonstein, and John Bigelow Taylor. *The White House Collection of American Crafts.* New York: Harry N. Abrams, 1995.

"News & Retrospect," *Ceramics Monthly* (March 1984): 77, 79.

Nzegwu, Nkiru. "The Legacy of African American Craft Art." In *Uncommon Beauty in Common Objects,* edited by Barbara Glass, 102-103. Wilberforce, Ohio: National Afro-American Museum and Cultural Center, 1993.

Nzegwu, Nkiru. "Living in a Glass House, Passing Through Glass." In *The International Review of African Art,* 45-51. Hampton, Va.: Hampton University Museum, 1994.

"The Organization of the Mackenzie Terrace Pottery Center," *Ceramics Monthly* (September 1980):111, 113.

Otton, William G. *Inside Texas Borders.* Corpus Christi: James R. Dougherty, Jr. Foundation, Corpus Christi State University, 1980, catalogue.

Recchia, Marisa, "Clay Heritage–African American Ceramics." *NCECA Journal* (1992-1993):86-87.

"Rock Art Revisited." *Southwest Art Magazine* (June 1989):105.

Sasser, Elizabeth Skidmore, "The Lubbock Lights Co-Op," *Artspace, Southwestern Contemporary Arts Quarterly* (Fall 1981):38.

Tyson, Janet. "Four Artists Plus 1 Show Feats of Clay." *Fort Worth Star Telegram* (February 25, 1990): 1, 5.

Untitled article. *Art Today, a Magazine of Fine Arts and Crafts* vol. 6, no. 3 (1992):30.

Up Front, "Contained and Uncontained," *Ceramics Monthly* (April 1996):20-21.

Watkins, James. " Pots Made of Memories." *Ceramics Monthly* (June-July-August 1992): 46-49.

————. "Cultural Grounding," 64-65. In *Collected Documents from ARTS REACH 90,* vol. 3. Austin: Texas Commission on the Arts, 1991.

————. "Remembrance." *The Studio Potter* vol. 24, no. 7 (June 1996): 28.

Weser, Marcia Goren. "New Visions." *San Antonio Light* (May 21, 1989): K-1, K-6.

Whitehead, Myrna. "Panorama." *Evening Journal-Lubbock Avalanche* (May 4, 1987):6-A.

Ziegler, Maria. "Texas Clay II." *Ceramics Art and Perception International Magazine* (September 1994): 80-83.

RADIO AND TELEVISION INTERVIEWS

KLRN-TV-PBS. *ART BEAT* No. 311. San Antonio: KLRN-TV-PBS, January 1993.

Phillips Production, Inc. *Texas Country Reporter,* Dallas: Phillips Production, October 2 and 3, 1993, syndicated program.

Thornton, Marva, producer host. "The Art of James Watkins" On *Take 5.* Lubbock: KTXT-TV.

INTERNET SITE

National Museum of American Art, Smithsonian Institution, Internet Artist Tour,
http://nmaa-ryder.si.edu/collections/exhibits/whc/Watkins.html (1999).

INDEX